JOSEPH GOLDYNE

JOSEPH GOLDYNE

ESSAY BY

PAUL CUMMINGS

JOHN BERGGRUEN GALLERY
SAN FRANCISCO

THOMAS GIBSON FINE ART LTD
LONDON

ROGER RAMSAY GALLERY
CHICAGO

DISTRIBUTED BY
UNIVERSITY OF WASHINGTON PRESS
SEATTLE AND LONDON

Distributed by University of Washington Press

ISBN 0-295-96910-5

Catalogue concept, research, and project coordination by
Anne Kohs & Associates, Inc.
Produced by Ed Marquand Book Design

All photographs by M. Lee Fatherree, Berkeley, California, with the exception of pages 14, 19, 30, 37, 45–46, 51, 59–60, 63, 76, 81, 95.

Joseph Goldyne's work is represented by:

John Berggruen Gallery
228 Grant Avenue
San Francisco, California 94108
(415) 781-4629, FAX (415) 781-0126

Thomas Gibson Fine Art Ltd
44 Old Bond Street
London, England W1X 3AF
(01) 499-8572

Roger Ramsay Gallery
212 West Huron Street
Chicago, Illinois 60610
(312) 337-4678

Questions regarding this publication should be addressed to:
Anne Kohs & Associates, Inc.
251 Post Street, Suite 540
San Francisco, CA 94108
(415) 981-6345, FAX (415) 981-4323

Printed and bound in Japan by
Nissha Printing Co., Ltd, Kyoto

Frontispiece: *The Books of My Numberless Dreams II
(from Yeats, "A Poet to His Beloved")*, 1989,
Prismacolor and graphite on paper, 21"h x 10¼"w
Private collection, Chicago
Page 7: *Studio, December 1987*, 1987,
drypoint with hand-wiped tone, 2"h x 2"w

TABLE OF CONTENTS

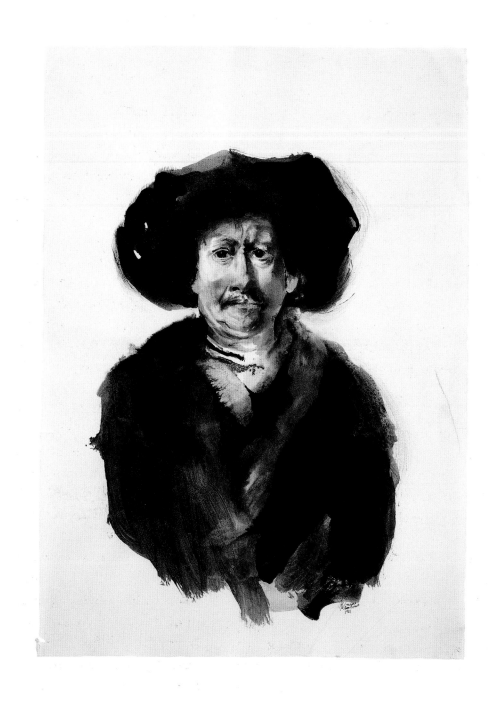

REMBRANDT

1969, INDIA INK ON PAPER
15 1/4" H × 11" W
COLLECTION OF THE ARTIST

PASSAGES OF CHOICE

In studying the lives of artists, one finds it is often family support or antagonism, meeting an artist, or the discovery of works of art in youth that inaugurates interest and provides stimulus for art. The choice may be motivated by a natural ability to draw, which most children have to some degree until they reach puberty, when it all changes. If this propensity to draw is continued with instruction, copying, drawing from illustrations or nature, and strengthened by the discipline of formal classes, we often find an evolving artist. Many youthful artists accumulate prints or drawings and books as a modest portable reference museum of their own devising.

Joseph Goldyne drew as a child, and he was blessed with parents who followed an avocation of painting and were always encouraging of their son's efforts. He remembers fondly what was a crucial childhood experience. When attempting to draw an apple he asked his father how to make it look "real." The response was, "Well, it's called shading," and he proceeded to show his son the technique. "That was about the most exciting thing I had ever seen. I was so turned on by that that I have always remembered it," said Goldyne.

He grew up in a San Francisco home with books, pictures, and a deep cultural awareness. Both of his parents painted abstractly. Because of his amblyopia, drawing became a substitute for outdoor sports that he soon came to love. This activity progressed on his own initiative. There were only two teachers he remembers who supported his interest. These were Mary Glunt at Aptos Junior High School, and Leonard Breger at Lick Wilmerding High School. They encouraged him but did not impose programmatic studies or formulas. In those years he also discovered that one "didn't become an artist," one followed an acceptable profession, or, like his father, became a surgeon. Art "was not what you made your living from, even though you might continue to draw or paint," he stated.

He therefore attended the University of California, San Francisco, where he attained an M.D. in 1968. Although he has a great respect and fascination for science and medicine, he came to the conclusion that he could not follow them to the exclusion of his art. The way to make a living was partly resolved with the thought that he might teach, but art history, not studio courses. Having received an A.B. in art history in 1964, he chose, after completing his medical degree, to continue his studies at Harvard University, and received an M.A. in fine arts in 1970.

An early work, *Rembrandt* (page 8), executed in india ink in a broad range of penumbral blacks and delicate grays, portrays the Dutch artist looking toward the viewer, with eyes slightly averted, almost as if this were a self-portrait. Applied in massed tones

with considerable freedom, the ink retains the brushy suggestion of abstract expression-ism, then nearing its end as the reigning style in American art. It is appropriate that Goldyne drew Rembrandt, for as a teenager he had evidenced a taste for prints and their making. He had gathered some prints for the purpose of learning about them, so that upon his arrival in Cambridge in 1968 he sought out a local fine printer, settling on Impressions Workshop. There he made his first prints. He began with black-and-white etchings, and soon shifted to monotypes and lithography. *Rembrandt*, with its isolated central image and deep tones, already suggests a natural graphic and painterly sensibility. This was to be explored and tested at Impressions.

When his printer, Robert Townsend, was temporarily incapacitated in 1970, Goldyne began to print his own etchings. The uneven wiping of a plate and improper printing provided a result that was monotype-like. "I never wanted to do a straight print again, because this was so much fun," he later commented. Chance proved to make him of the times. Monotype was in the air at Harvard because of *Degas Monotypes*, a 1968 exhibition and catalogue by Eugenia Perry Janis. Goldyne acquired a copy of the catalogue. The monotype process is one where oil paint, gouache, printing ink, or even watercolor is worked on an impervious surface—usually copper or zinc—and then run through a press. If done on glass, the image may be printed by placing a piece of paper over the painted glass and applying pressure with a brayer or the back of a spoon. This process normally produces one print, hence its name. Occasionally a second or "ghost" image can, with care, be elicited from the plate. Traditionally the faint print is reworked by the addition of pastel, pencil, ink, or other image-enriching and clarifying procedures.

Goldyne had applied to Harvard because of the Fogg Museum and its great drawing collection. Having majored in art history as an undergraduate at Berkeley, he realized that most graduate students would be working with books and slides, whereas he wanted to see and feel the actual drawings themselves. Goldyne, who loved prints and books, man's creations of a modest and manageable size, was enthralled by the availabil-ity of the collection at the Fogg. This attitude probably also influenced the size of many of his own works. Because of this taste for books, many of the early prints are narrow and vertical, echoing the format of the books. His was a singular aesthetic position in the decade of large canvases and increased commercialization of print publishing, when prints were often issued as surrogates for painted images.

In 1970, Goldyne returned to San Francisco. He commenced making monoprints and monotypes at the studio of Jeanne Gantz, in Berkeley. Goldyne differentiates between monoprints and monotypes in the following manner. Monotype does not incorporate any other graphic process such as etching, drypoint, or aquatint. The monoprint, on the other hand, results from a surface prepared by a combination of techniques. At least one of these must exclude the possibility of reproducing identical impressions. Thus, an

aquatint, drypoint, or etching plate may be further elaborated by finger and/or brush painting, thereby producing an impression which is quite unrepeatable. He has chosen to call these impressions "versions," for they are variations of the single concept expressed by the fixed intaglio image on the plate.

In the early 1970s Goldyne developed a large group of prints which demonstrated his interest in art history and collecting, and often employed images in homage to artists he respected. His work is very independent of what is usually seen as representative of California art. There are no airbrush tricks, aggrandizements of the landscape, or figures depicted in either boldly textured or slick painting or drawing styles. His drawings and prints persist in proclaiming the hand of the artist, continuing the intimacy of contact he found in books and old master prints. The prints have never been examples of modern printing house techniques of mass, though skilled, production.

His first prints were made in black and white until late 1971 or early 1972 when color began to appear. The dramatic theatrical quality which is obtainable in monoprints held a great appeal for Goldyne. "It is like stage lighting where the set remains the same and the mood is changed by the lighting alone." To accomplish this he uses not only a brush for applying color, but also the tip of a finger, which records the slightest sense of motion. As a self-described "romantic," he explains his enchantment. "In terms of classical eighteenth-century romanticism, a romanticism of contrasts and darkened passages and dramatic scenes, there is nothing like monotype." It is in this romantic vein that he elicits variations of rich dramatic emotional and intellectual appeal.

In 1972, he produced his first book, *Gathering the Decade*, a volume of illustrated poems published by Goad Press and printed by the Grabhorn-Hoyem Press. Consistent with his bookish turn of mind, it is appropriate that this first of many volumes should also contain his writings.

It was only in 1973 that he was given his first one-man exhibition of monoprints at the Quay Gallery in San Francisco. This selection proved a stunning success, selling out within twenty-four hours. The exhibit stimulated an interest in monoprints in other artists. Early in the century, there were a number of northern California painters who produced monotypes, but while contemporaries such as Nathan Oliveira had previously explored the process, this exhibition, consisting solely of monoprints, brought the technique to the attention of a wide public. Because Goldyne's prints were now available to this public, they were selected for exhibitions such as the Davidson (College) National Print and Drawing exhibition where that same year Goldyne received a purchase award from the critic Clement Greenberg.

While his prints continued to affirm an interest in the works of old masters or literary sources, they also now began to engage his views of the city in which he lived and locations he visited. Subject matter is always prominent in the mind of a realist, for it is

in resonance with his subconscious and appears as the result of obvious choices. There is a great variety of subject matter in Goldyne's art, including views, landscapes, flowers, portraits, and architectural fragments. One is reminded that the most prominent, in various guises, is still-life.

Of his frequent use of common objects, he states, "I think setting common objects in a rarefied atmosphere is a worthwhile task." There is often the technical challenge to achieve the look of glass, of reflections, of the living flower, of making the image come alive, and, under this close scrutiny, to present, as Charles Sterling, the leading still-life expert says, "the thrill of sensual pleasure." Still-life is traditionally directed toward the minute examination of objects, surfaces, color, and the play of light on nature, flowers, fruits, plants, and man's handiwork, silver, furniture, paper, stamps, documents, food stuffs, signs of wealth and labor. Visible, viable virtues of the world such as the simple croissant, coffee, and crisp linen napkins offer warmth and nurturing hospitality. Nevertheless, the common objects which furnish many a pictorial image of enlightenment or luxury have led in their visual expression to despair, and not to life enhancement. Goldyne's natural joy replaces such dark Spanish or compressed Dutch feelings with a liveliness one would expect from California and from America.

In such relatively early works as *Smog Alert Over Santa Monica Freeway—Turner's Ship Steaming Ahead* (page 13), of which there are several color monoprint versions, a methodology of juxtaposing contradictions emerges. An idea is presented which will be developed with great wit and imagination in the coming years. The heavy flow of traffic in the lower portion of the composition and the vast ship in the sky suggest the effects of collage, though it is all drawn. This design records an image which passed through the artist's mind while driving along the Santa Monica Freeway. At one time he had the notion that the countryside of California needed someone to record and celebrate it anew. This, then, is an early manifestation of that impulse. It is also another in a long, disjointed series of homages to significant figures in his pantheon of artists of the past. He uses these fragments to blend the present with the past, to formulate a quality of humor which is rare in art and could only have occurred after the rise of the Dada and Surrealist conceits. Before those modern schools, the response would have been, "How dare he!"

The visionary aspects of his art should not be slighted. In this marvelous image, above the freeway's clouds of smog, that *mal de mer* colored gas that infects the sky, moves Turner's ship, which was originally cloaked in the less noxious clouds of fog rising from the Atlantic. Turner painted his picture, *Peace—Burial at Sea* (1842), now in the Tate Gallery, in homage of his friend the painter Sir David Wilkie, who died on a vessel off Gibraltar and was buried at sea. There is not infrequently a dark foreboding aspect to Goldyne's images. *The Temptation Over Tamalpais* (page 29), a color monoprint, depicts a favorite view, but also serves as a mystic symbol of his vision of northern California.

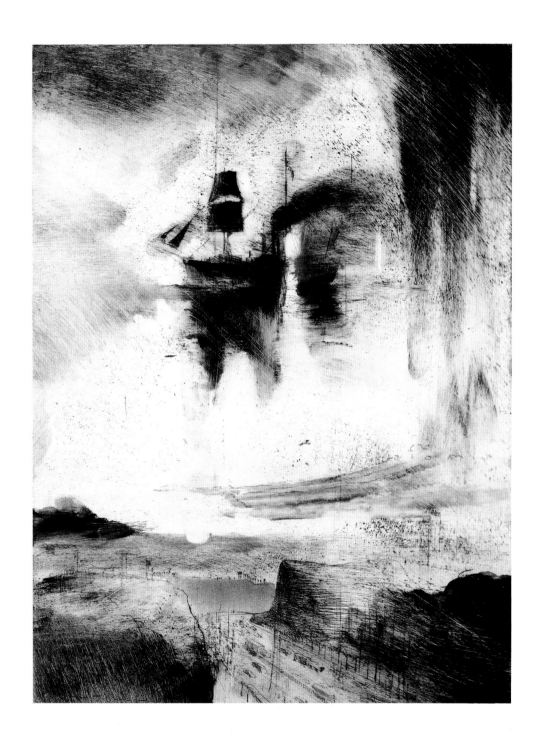

SMOG ALERT OVER SANTA MONICA FREEWAY—
TURNER'S SHIP STEAMING AHEAD
(VERSION 2)

1973, MONOPRINT: ETCHING AND MONOTYPE
IMAGE: 11⁷/₈"H × 8⁷/₈"W
COLLECTION OF THE ARTIST

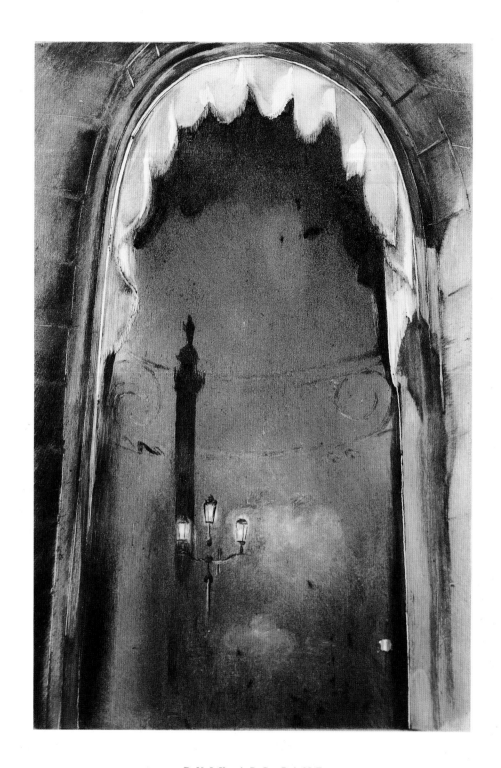

DUSK ARC PANE

(FROM *NIGHT LIGHTS*)

1979, MONOTYPE
IMAGE: $8^3/4''$ H × $5^3/4''$ W
PRIVATE COLLECTION, LOS ANGELES

14

This imagined fantasy, formed in the air over a mountain Goldyne admires as much as Cézanne did his Mont Saint-Victoire, is a riotous event in the calm morning sky, an incident of magnitude taking place without concern for the relentless flow of traffic below. In these fragments from Bosch we sense more than a war of the worlds. It could be viewed as a conflict of the spirit.

Other images with this smoldering cast, such as *Hollywood Gothic* (page 32), and *Skin and Bones: Stubbs and Courbet Rendezvous at Ornans* (page 27), denote various mixed feelings toward the meaning of realism in our time. Combining Stubbs's serious interest in the supportive architectural aspects of the skeletal system with the charms of a work attributed to Courbet, Goldyne hints at the eternal conflict between life and death.

To support his juxtaposition he finds historical precedent not in collage, or Surrealism, of which he is apprehensive, but in the famous painting by Albrecht Altdorfer in the Alte Pinakothek, Munich, *The Battle of Issus* (1529), in which a great escutcheon hangs in the sky. "I think it's one of the greatest visual ideas ever," Goldyne has said. Indeed the pictorial width of that shield not only balances the composition, but the startling juxtaposition facilitates remembering the image. As with so many artistic inventions, they soon become conventions. Visual drama, it is readily apparent, is of great concern to Goldyne. He always looks for and attempts to establish a magical quality in his art. Frequently, this can be experienced in the atmospheric luminosity and the knowing juxtapositions of components or in the skillful rendering of subjects. It is secured in the sagacity that enlivens the imagination evident in his plates.

One might well be led astray to read overt symbolism or hidden agendas in these complex compositions. The poetics of his imagery has to do with romanticism, a quest for beauty, for the image and effect that will stimulate the eye, the mind, and the spirit, bringing joy to the viewer just as it brought joy to its maker. The intimate size and vertical formats reveal his preference for an expression which is contained, like the human figure. The images continue a hermetic pictorial language scaled to books. "It never occurred to me to do a Rembrandt the size of a Rembrandt," he states in discussing the often-intimate physical size of his works. There is a warmth of recognition in many of these sheets of things known to one and all.

But there is also a series of designs which illuminate a privileged life. These, too, are of modest size. An image such as *Dusk Arc Pane* (page 14), one in the series *Night Lights*, an album of ten color monotypes, reveals a view into the Place Vendôme from the Ritz Hotel. It captures the high romance of Paris and its misty, dusty gray light in the crepuscular transition of day to night. Works such as these remind one that Goldyne does not harvest his knowledge in art history to the exclusion of real life and daily experience. And it is these latter qualities which unite all his work and sustain our interest.

The color monoprint with etching, *Jolie: P.P. and BLT* (page 31), presents a grasping

figure adapted from a Picasso painting of 1929. This fragment illustrates, as do so many others, Goldyne's interest in passages, "that is, modest sections of masterworks," in which he observes the fully realized aspect of the artist's aim. Not all areas of a masterwork are equally accomplished, hence his concern with the selection of refined passages which become, like the prints and drawings he has gathered, things of artistic use. They are keys to suggestions, solutions to graphic problems, and they provide him with stimulating technical achievements.

Nuance of idea and execution are essential aspects of both his prints and drawings. One of the wittiest displays of this is seen in *The Spirit of St. Louis—Morris Lifted Over Caspar Friedrich's Horizon* (page 29), a colored monoprint. Here Morris Louis's diaphanous veils of stained color are set above the German romantic artist's landscape, producing the effect often seen in nature of the sun's rays falling through the clouds. Putting the color field painting in the sky transforms it, in effect, into the aurora borealis shimmering in the night sky. Nuance is seen too with *Ruscha and the Number One Impressionist* (page 33), where Goldyne spells out the name of Monet in a sans-serif outline type face spaced over a London bridge, set in a thick atmosphere. Edward Ruscha is noted for his play on words and the imaginative use of letters. The wit of supporting one artist's image on the image of another is a delightful manifestation of provocative whimsy.

Without question, monotype became Goldyne's preferred version of the painting process. "In the way I do monotypes, it's not the color put down initially, it's the glazes of color left after much pigment is removed that give the final image and also allow the color of the paper to come through," he states. Chance is present in

> the moment after pulling the print, before one lifts the paper from the plate, when you wonder if the right tone and texture of paper has been chosen, if it's the correct thickness of pigment, if the pressure of the press was too great or too little; and there's the hope that maybe a second impression will emerge that can be worked up by the addition of more drawing or different printing processes. If a passage is too dry I apply pastel or watercolor, which models the form even more.

Beginning in about 1975, Goldyne added the aquatint process to his etched lines. Monotype color worked into the aquatint tone embellished the spare etched line and became an increasingly important technical aspect of his prints. His colored drawings display a similar sense of modeling and spatial considerations. But his increasingly wide technical range and skills were not of themselves important; it was only that they would better aid the achievement of what he conceived.

By 1976 he discovered the pleasure of celebrating his own city. The mountains, the weather, the ever-changing atmospheric effects of clouds, rain, light, fog often occur in

quick succession. An early example of this is *A Setting for San Francisco* (page 30). The silver, wrapped in a stiff linen napkin and bound with a colorful ribbon, sets the style of a cuisine directed toward a significant, if not glamorous, food presentation. How charmingly the table setting hangs in the sky over the city, thrust forward in greeting, a heavenly body of sorts, or as the metropolitan escutcheon for a local obsession.

There is an easy western natural elegance about the way Goldyne works and progresses through the day. This is revealed in the precise care he takes with every action. It has to do with innate style, with thinking, and with making intelligent choices. An example of this is an intimate domestic drawing, *Debbie, Ritz, Paris* (page 104). This portrait drawing, with its clear profile and delicate but firm shading, echoes the drawings of Ingres or even the portraits of Holbein, in its efficiency and in its revelation of the nature of the sitter. For all the intellectual awareness which informs Joseph Goldyne's art, the romantic nature of the artist is never hidden or rejected. This truth to nature gives his art high value and true substance.

Romanticism is a distinct characteristic of Goldyne's art. In referring to himself as "a romantic," Goldyne describes his

> awareness of the formal literary and artistic concept of romanticism from the
> eighteenth century on. I think what it probably means for the individual is
> the ability to be self-indulgent, in the best sense of the word: the ability to
> spend the time to fulfill one's own potential and to proceed along lines that
> give one a certain amount of joy in doing.

He counterbalances this with the statement that "in terms of the history of ideas, the truly great contributions of my period emanate from the sciences." But in his heart, he is no longer directly concerned with those ideas, "because they are no longer romantic. They involve man's mind and its situation in the greater universe rather than man's relationship to his fellow man and the universe of the spirit. I may be on the brink of dealing with the implication of recent science, but like religious imagery, visual references to the sciences seem too easy, too hackneyed. It is a special challenge."

The study of art history, as we have seen, has given Goldyne a vast repository of images, styles, and facts to employ in the making of his art. Three prints, *Steps to Cubism I, II,* and *III* (page 36), reveal his grasp of the older style. His sense of playfulness stimulates marvelously inventive transformations in his dialogue with history. The bald contrast of a three-dimensional apple in a cubist composition, or the origami of tilted planes, suggesting more than revealing, manifest an intellectual understanding of the modernist concepts while the drawing qualities themselves exhibit a felt experience of such works of art. But unlike cubism, which maintained closed pictorial values, Goldyne springs forth with a brightly colored apple in the clear tones of pink, red, and rust.

Among the recurring motifs are flowers, subject material with which he maintains a love/hate relationship. Tulips, irises, chrysanthemums, as well as exotic tropical plants discovered during travels, all find a place in his archive of images. Often his flowers, such as *Night Pinks* (page 59), are sited in niches. These small oval-topped wall indentations are a compositional device which dates to those painted by Taddeo Gaddi in Santa Croce in 1337–1338, and are to be found in many of Goldyne's flower compositions. Even the flowers which seem to be isolated in space are set in a swirling mass of richly colored tonal background colors which contain them. The floating quality might echo his interest in the work of Redon. Diaphanous forms coalesce in evanescent clouds of color as their focus shifts.

In 1976 Goldyne began to produce a series of elegant monotype books, unique volumes of prints made mostly for his family or very close friends. He also began a wry series of editioned works commenting nominally on the art of printmaking, but more specifically taking aim at problems besieging the visual arts in general. *Ten Firsts in the History of Printmaking* (1976–78) clearly illustrates his control of the media he chose to employ. The witty images, purposefully small, have appended to them detailed titles in a language which alludes to conceptual art as much as to the eighteenth century. The first plate, for example, is called *The first intaglio Cubist image impressed on a chine-collé preparation against a maroon field suggesting a note of fenestral sanctity* (page 34). They continue: *The first faintly emergent nude couple rendered in spit-bite, softened with acid wash and minimally delineated by drypoint accents* (page 35); *On: The first post-Johns incandescent bulb fashioned in spit-bite and drypoint and depicted, with the aid of à la poupée coloring, to characterize its illuminated state* (page 35), and so forth.

> These ten images and their titles were conceived to point out the fallacy of approaching innovation for innovation's sake, an approach which I had perceived too frequently in the supportive critiques of formalism and in the banter of artists. By employing titles that were highly specific and which smacked of the lingo of conceptual art, and by attaching these to intimately conceived, frankly precious miniatures as opposed to ambitious images, I was pointing out via ironic linkage the often flailing pomposity of much contemporary pictorial art and therefore its ultimate failure as serious visual art.

It is characteristic of Goldyne, in his desire to present this severe critique in bold visual terms, that the results are at once beautiful and amusing.

By 1980 a series of larger, complex still-life motifs which could be read as interior portraits of the artist's presence began to emerge. Among these are *Bedroom Sweater Closet* (page 19), which shows shelves of sweaters held in the firm grasp of the cabinet's geometry. Hints of similar concern with domestic imagery can be found in the paintings

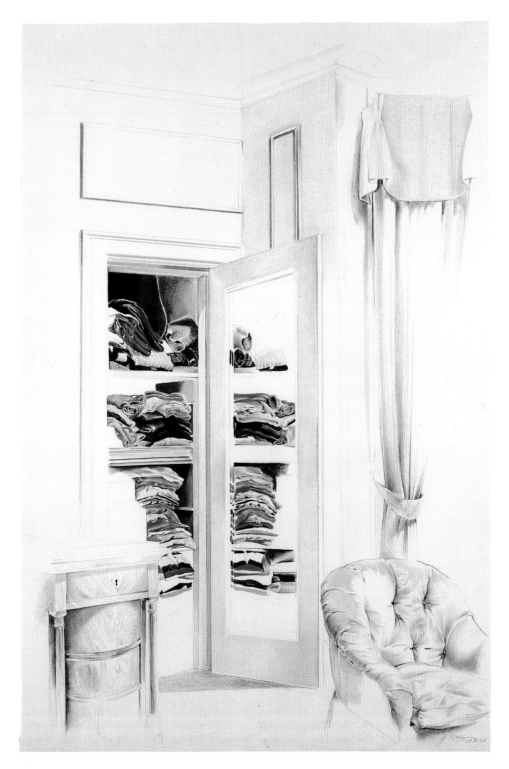

BEDROOM SWEATER CLOSET

1980, PRISMACOLOR AND GRAPHITE ON PAPER
21 7/8" H × 14 1/2" W
PRIVATE COLLECTION, SAN FRANCISCO

19

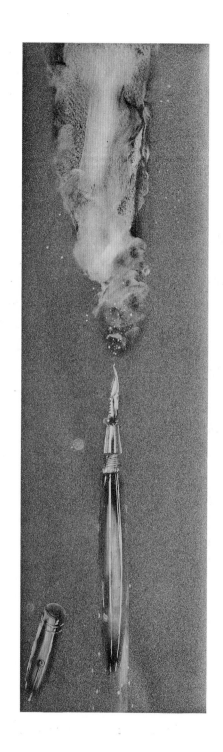

SMOKING PEN
(FROM *HET ACHTERHUIS /*
ANNE FRANK: DIARY OF A YOUNG GIRL)

1985, ETCHING, DRYPOINT, AQUATINT,
À LA POUPÉE
IMAGE: 9 1/4" H × 2 3/4" W
COURTESY OF PENNYROYAL PRESS,
WEST HATFIELD, MASSACHUSETTS

of Vuillard and Bonnard. This trait continues even in drawings made during travels, such as views of Jerusalem through a window, made during a trip there. Because of his historical sensibility, one might suggest that he knows of the noted drawing of 1787 by J. H. W. Tischbein of his friend Goethe standing with his back toward the viewer, gazing out the window of his Rome apartment. In the *Fensterbild*, the figure was soon to be lost, and only the room's interior and the distant landscape remained. While this inner and outer view of man and nature contributed to nineteenth century romanticism, it is rarely noted in American art. Other works, such as *View Toward Cul de Sac, San Francisco* (page 92), sustain this point of view.

Of all the flowers, tulips seem to have made lasting impressions on Goldyne's vault of subjects. *Open Parrot* (page 66), *Night Choir* (page 67), and *Opening*, all dated 1983, examine this ever-changing flower in its multiple stages of development. Most of these are aquatint and drypoint plates in color, save for those to which monotype is added. And the tones are usually penumbral with bright whites or reds. Their deep tonal backgrounds remind one of Charles Sterling's comment in his monumental work on still-life that "gray is the philosophy of colors." The dark backgrounds also suggest a delight in Dutch taste. And yet, we see in the flower itself a ripe animism whose light often rises from within. We realize that Goldyne is not concerned with the scientific depiction of specific species, but in relating the feeling of what a tulip is.

At the behest of Lewis Shepard, he undertook his most monumental book project in 1985. This was to create images for *Het Achterhuis / Anne Frank: Diary of a Young Girl*, published by the Pennyroyal Press with the Jewish Heritage Publishing Company. Designed by Barry Moser, printed by Harold McGrath, and illustrated with ten etchings by Goldyne, an edition of 450 volumes was issued, each accompanied by an additional suite of prints in a quarter-leather chemise matching the book's binding. It is an impressive job of printing and production. To refine his imaginative point of view, Goldyne traveled to Amsterdam to view the house which is now a museum. He chose images which recall not only the plight of the young girl, but images that have a long history.

Smoking Pen (page 20) certainly relates to the Emily Dickinson image in her poem, "My Life had stood—a Loaded Gun." In another plate, the house itself, seen from the air, is set off from the others by its color rather than by any architectural distinctions. The remaining images take on new meanings because of their context. Other books were to follow, but this will remain a significant aspect of his work, and a brilliant example of bookmaking.

The homages to mentor figures has continued recently with portraits of admired artists and writers based on photographs. *Hugo Musing*, a drypoint, began the series. Its drawing is suggestive of the artistic styles during the poet's lifetime. This is a small format fit for the frontis of a collected works. But the subject of the great writer-artist

was also among the first large monotypes and pastel portraits Goldyne created at Magnolia Editions in Oakland beginning in 1987 (see *Victor Hugo*, page 23). At forty-one by twenty-eight and a half inches, it is the beginning of a new phase of monumental prints and drawings. The pensive, perplexed Henry James, depicted in a 1987 pastel and pencil on colored paper (page 84), shows us the profile of the onetime art writer and transatlantic novelist. One of the liveliest of these reviews of significant personages is *Odilon Redon* (page 82). The master of pastel and tonal atmospherics is revealed in a monotype with pastel, also on a large sheet. The sepia color suggests an aged photograph, save for the colorful flower, an enlivening note of red at the lower center of the composition. While Goldyne obviously refers to photographs for his portraits, they are considered notes, rather than images to be slavishly copied. Another large monotype, *Kollwitz* (page 78), is a charming, but severe view of this woman. In a recent drawing, *Eakins Taking Questions* (page 74), he has conflated the artist into the position of Dr. Gross in Eakins's famous painting, *The Gross Clinic* (1875), replacing the doctor's scalpel with the artist's equally incisive chalk. Here are contrasting fields, but equality of genius.

Large monoprints of flowers have become an important series for the artist during the last few years. These have been done at Magnolia Editions in Oakland, California, where Don Farnsworth introduced Goldyne to the possibilities of the large intaglio and reproofing presses at the studio. The florals have been executed on two sides of a single, thick copper plate, forty-seven and a half by thirty-five inches in size. One side of the plate has been inscribed with a drypoint image of a pot of tulips (see pages 60–63); the other side holds a drypoint of a nasturtium plant (see page 64). Goldyne chooses the side of the plate he feels like inking and elaborating, the drypoints providing only the linear foundations for monotypes to which he adds pastel and watercolor. These mixed media works achieve richly varied surfaces, focusing attention on regal and glowing flowers.

The quality of life represented in the work of Joseph Goldyne is rare today. Cultured, enthusiastic, vital, educated, and discriminating—Goldyne possesses qualities which have slipped from American art in the past eight or so decades. Confronting the garish products offered to what appears to be a public ever hungry for racy novelty, Goldyne seems a bit old-fashioned. Yet in that very quality he retains the values which have a much longer history and a deeper impact on human life than the neon glamour of much of the present. His painterly prints capture the delights of California, the joys of travel and fine food, and the sorrow of a young girl's tragic life. There is a sense of nature in the role of landscape and waterscape in his plates, depicted not with a harsh northern sensibility, but one which is truly that of a gentle Californian. Although these are modern works, history hangs like a shimmering curtain of illumination in the background of the mind which envisioned these images. This context enriches the experience for everyone.

<div align="right">PAUL CUMMINGS</div>

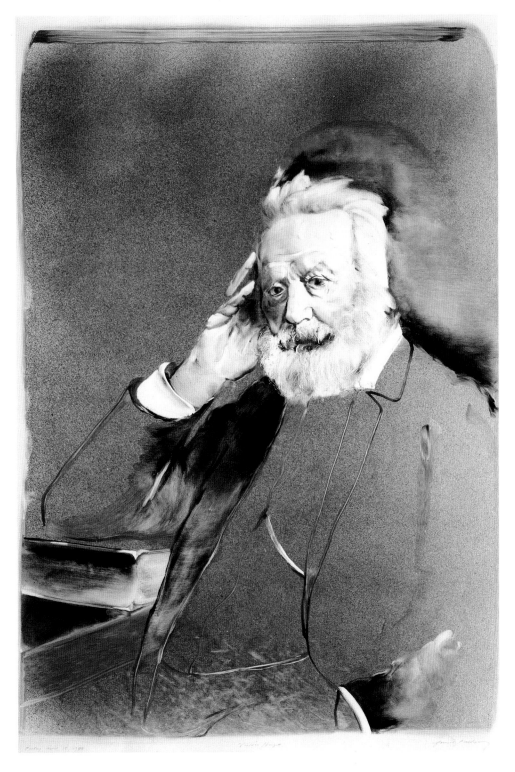

VICTOR HUGO

1988, PASTEL OVER MONOTYPE
IMAGE: 41"H × 28 1/2"W

23

EARLY WORKS

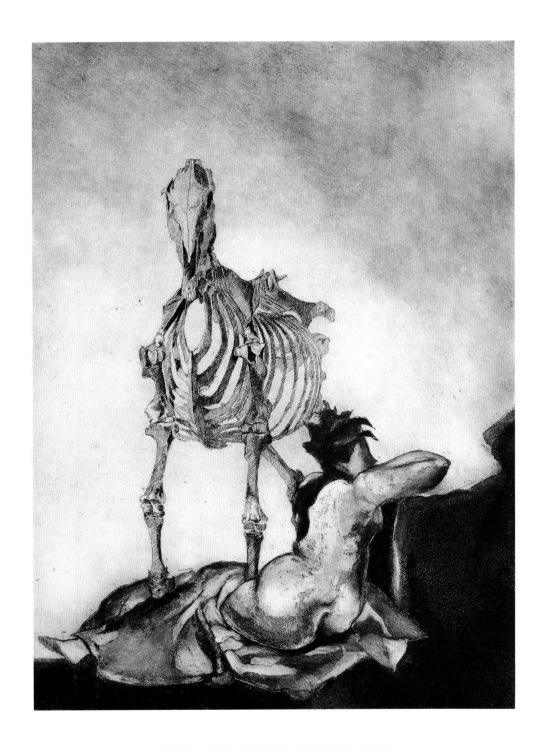

SKIN AND BONES: STUBBS AND COURBET RENDEZVOUS AT ORNANS

1975, MONOPRINT: ETCHING, AQUATINT, MONOTYPE
IMAGE: $11\,3/4''\,\mathrm{H} \times 8\,7/8''\,\mathrm{W}$
PRIVATE COLLECTION, SAN FRANCISCO

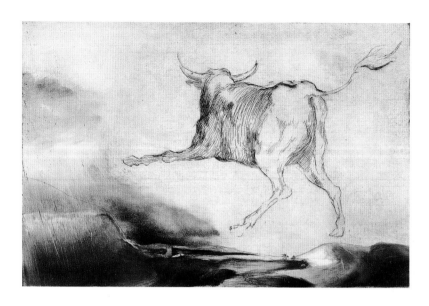

GOYA'S BULL COMING IN OVER MARIN
(VERSION 8)

1973, MONOPRINT: ETCHING AND MONOTYPE
IMAGE: 5$^7/8$"H × 8$^7/8$"W
PRIVATE COLLECTION, SAN FRANCISCO

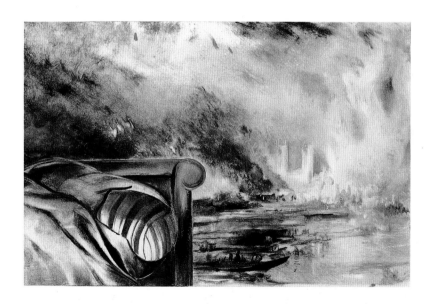

LITTLE NINETEENTH CENTURY
NIGHTMARE VIGNETTE

1977, MONOTYPE
IMAGE: 5$^7/8$"H × 9"W
COLLECTION OF THE ARTIST

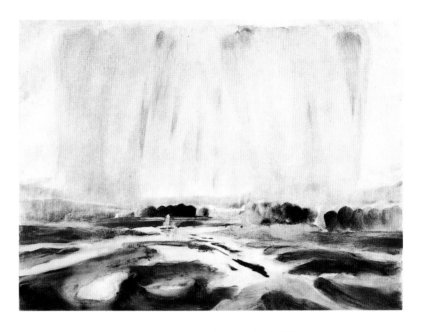

THE SPIRIT OF ST. LOUIS—
MORRIS LIFTED OVER CASPAR
FRIEDRICH'S HORIZON

1973, MONOPRINT: ETCHING AND MONOTYPE
IMAGE: 8 7/8″ H × 11 7/8″ W
PRIVATE COLLECTION, SAN FRANCISCO

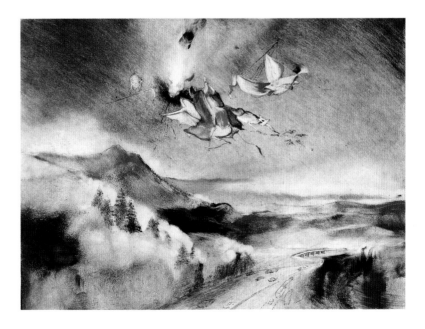

THE TEMPTATION OVER TAMALPAIS
(VERSION 2)

1973, MONOPRINT: ETCHING AND MONOTYPE
IMAGE: 8 7/8″ H × 11 7/8″ W
PRIVATE COLLECTION, SAN FRANCISCO

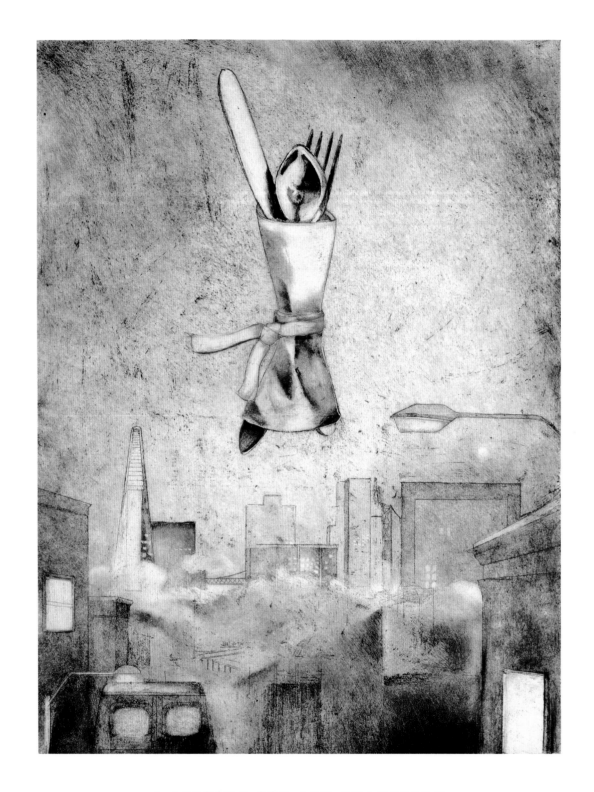

A SETTING FOR SAN FRANCISCO
(VERSION 1)

1976, MONOPRINT: ETCHING, AQUATINT, MONOTYPE
IMAGE: $11^{3/4}''$ H × $8^{7/8}''$ W
PRIVATE COLLECTION, SAN FRANCISCO

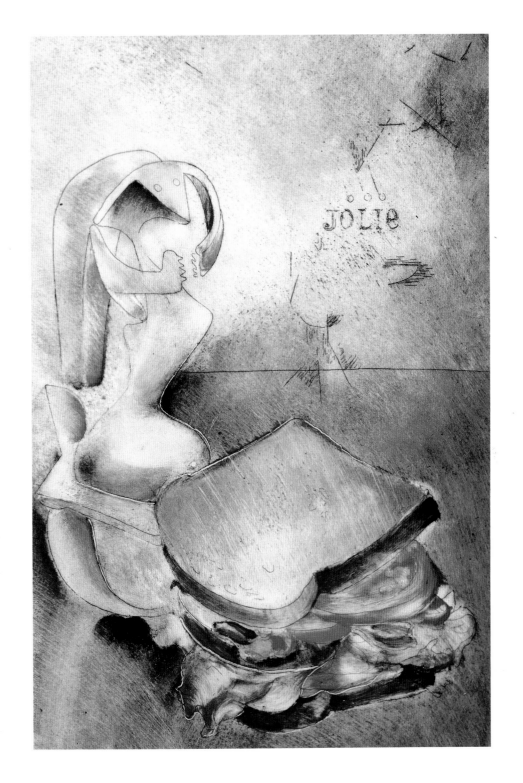

JOLIE: P.P. AND BLT
(VERSION 3)

1973, MONOPRINT: ETCHING AND MONOTYPE
IMAGE: $8^{3/4}''$ H × $5^{7/8}''$ W
COLLECTION OF THE ARTIST

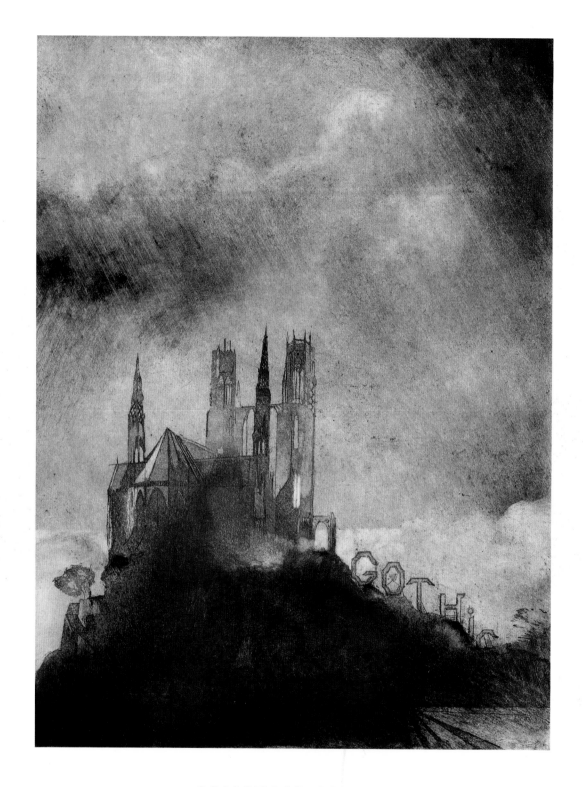

HOLLYWOOD GOTHIC

(VERSION 1)

1975, MONOPRINT: ETCHING, AQUATINT, MONOTYPE
IMAGE: 11 3/4"H × 8 7/8"W
PRIVATE COLLECTION, SAN FRANCISCO

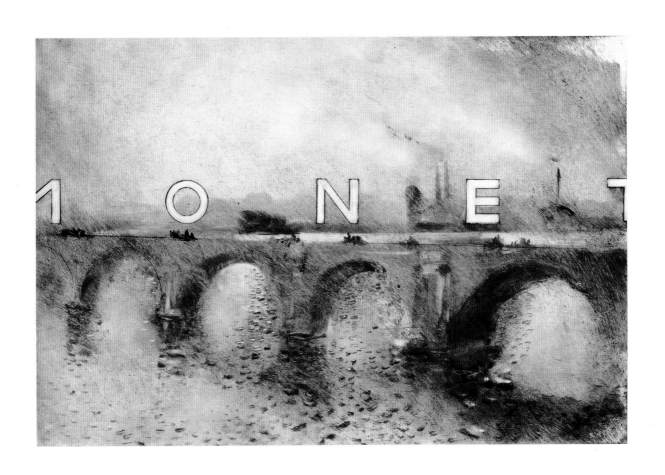

RUSCHA AND THE NUMBER ONE
IMPRESSIONIST
(VERSION 1)

1974, MONOPRINT: ETCHING AND MONOTYPE
IMAGE: $11^{7}/8''$ H × $17^{3}/4''$ W
COLLECTION OF THE ARTIST

33

THE FIRST INTAGLIO CUBIST IMAGE
IMPRESSED ON A CHINE-COLLÉ PREPARATION
AGAINST A MAROON FIELD SUGGESTING A NOTE OF
FENESTRAL SANCTITY
(FROM *TEN FIRSTS IN THE HISTORY OF PRINTMAKING*)

1976, AQUATINT, DRYPOINT AND ETCHING,
PRINTED CHINE-COLLÉ
IMAGE: 7"H × 5 1/2"W
COLLECTION OF THE NEW YORK PUBLIC LIBRARY

THE FIRST FAINTLY EMERGENT NUDE COUPLE
RENDERED IN SPIT-BITE, SOFTENED WITH ACID
WASH AND MINIMALLY DELINEATED BY DRYPOINT
ACCENTS

(FROM *TEN FIRSTS IN THE HISTORY OF PRINTMAKING*)

1976, SPIT-BITE WITH ACID WASH, DRYPOINT,
PRINTED CHINE-COLLÉ
IMAGE: 3 15/16" H × 5 15/16" W
COLLECTION OF THE NEW YORK PUBLIC LIBRARY

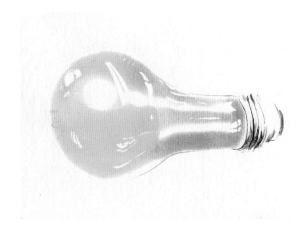

ON: THE FIRST POST-JOHNS INCANDESCENT BULB
FASHIONED IN SPIT-BITE AND DRYPOINT AND
DEPICTED, WITH THE AID OF À LA POUPÉE
COLORING, TO CHARACTERIZE ITS ILLUMINATED
STATE

(FROM *TEN FIRSTS IN THE HISTORY OF PRINTMAKING*)

1976, SPIT-BITE AND DRYPOINT, PRINTED CHINE-COLLÉ,
À LA POUPÉE
IMAGE: 2 7/8" H × 3 7/8" W
COLLECTION OF THE NEW YORK PUBLIC LIBRARY

 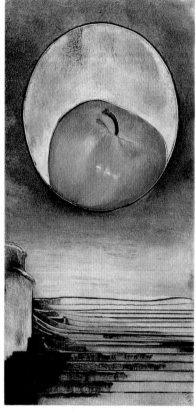 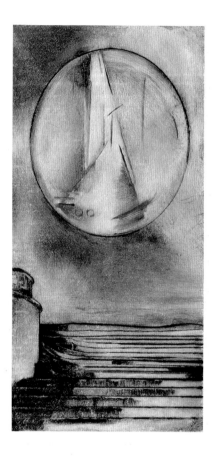

STEPS TO CUBISM I STEPS TO CUBISM II STEPS TO CUBISM III

1978, DRYPOINT
IMAGE: 6"H × 2^{15}/$_{16}$"W

1978, PRISMACOLOR ACCENTS
OVER MONOPRINT: DRYPOINT
AND MONOTYPE
IMAGE: 6"H × 2^{15}/$_{16}$"W

1978, MONOPRINT: DRYPOINT
AND MONOTYPE
IMAGE: 6"H × 2^{15}/$_{16}$"W

THE PASSING OF THE AGE
OF CUBISM — A STRAWBERRY PRESIDING
(VERSION 2)

1973, MONOPRINT: ETCHING, DRYPOINT, MONOTYPE
IMAGE: 8 13/16" H × 11 7/8" W
COLLECTION OF THE ARTIST

STILL LIFES

CAESAREA, MAY 1983

1983, PRISMACOLOR AND GRAPHITE ON PAPER
11⅛"H × 15"W
COLLECTION OF THE ARTIST

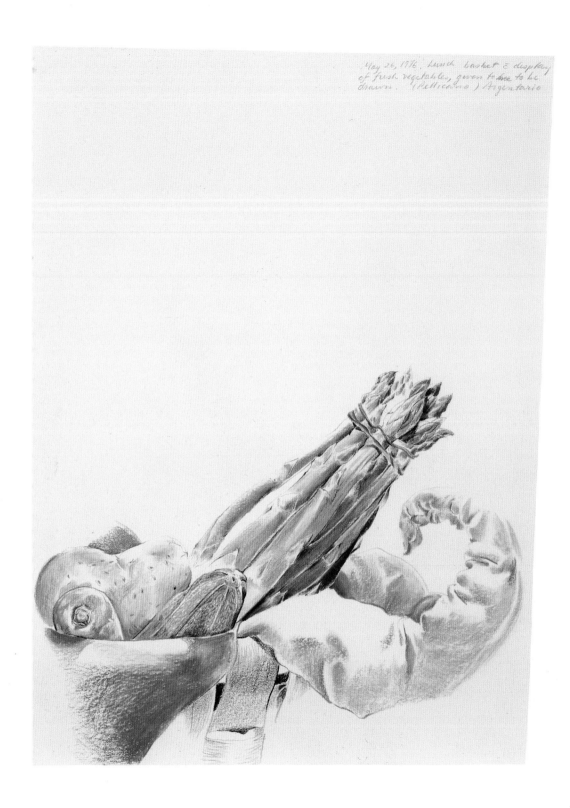

May 26, 1976. Lunch basket & display of fresh vegetables, given to me to be drawn. (Pellicano) Argentario

STILL LIFE, ARGENTARIO

1976, PRISMACOLOR ON PAPER (IN SKETCHBOOK)
12"H × 9"W
COLLECTION OF THE ARTIST

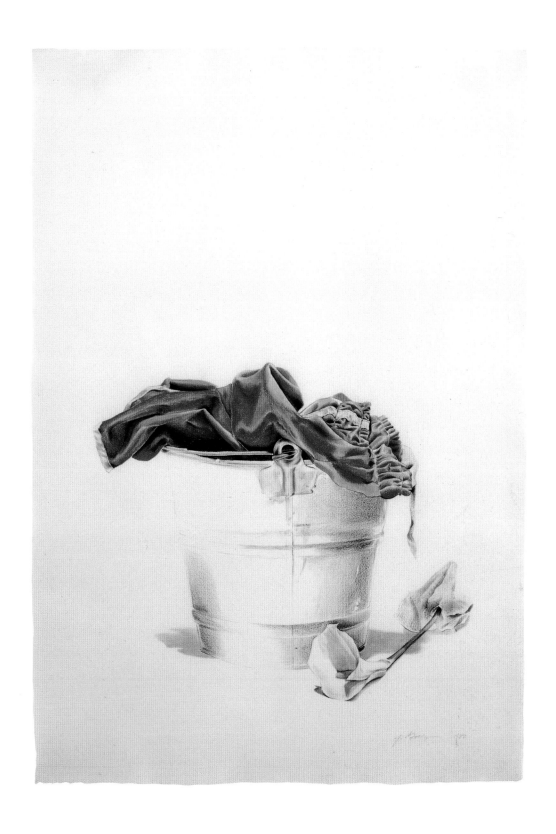

PAIL, TRUNKS AND LILY

1980, PRISMACOLOR ON PAPER
20³/4″H × 16¹/4″W
PRIVATE COLLECTION, SONOMA, CALIFORNIA

43

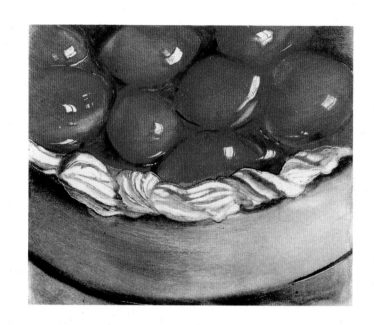

FLAN

1979, MONOTYPE
IMAGE: $2^{15}/_{16}$" H × $3\frac{1}{2}$" W
PRIVATE COLLECTION, SAN FRANCISCO

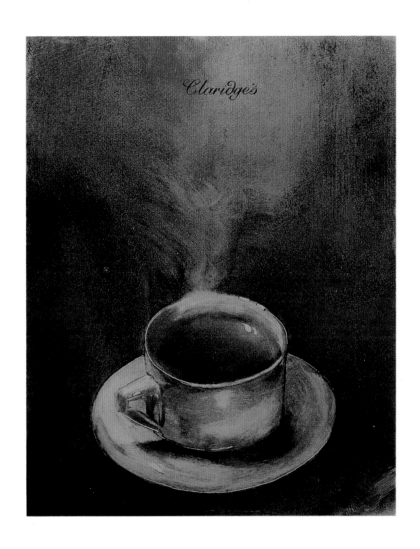

RECOLLECTION OF COFFEE IN LONDON

1981, MONOTYPE PRINTED CHINE-COLLÉ
IMAGE: 5"H × 4"W
PRIVATE COLLECTION, LONDON

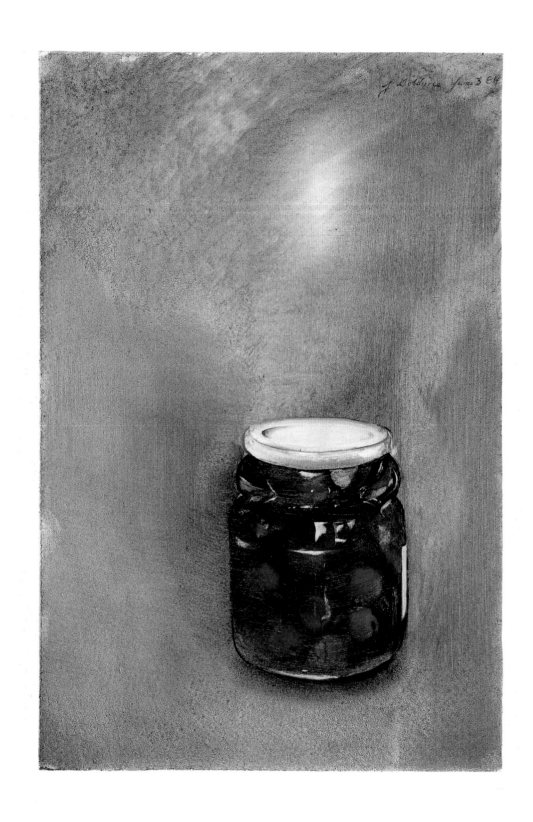

CHERRIES AND SYRUP

1984, OIL PAINT ON GESSOED PANEL
12"H × 8"W
PRIVATE COLLECTION, SAN FRANCISCO

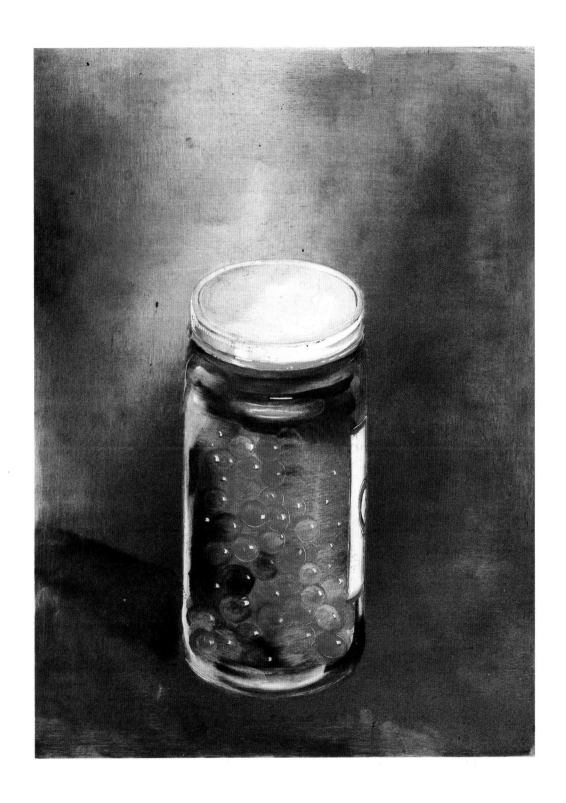

JAR OF CHERRIES

1988, MONOTYPE
IMAGE: 11 7/8" H × 8 15/16" W

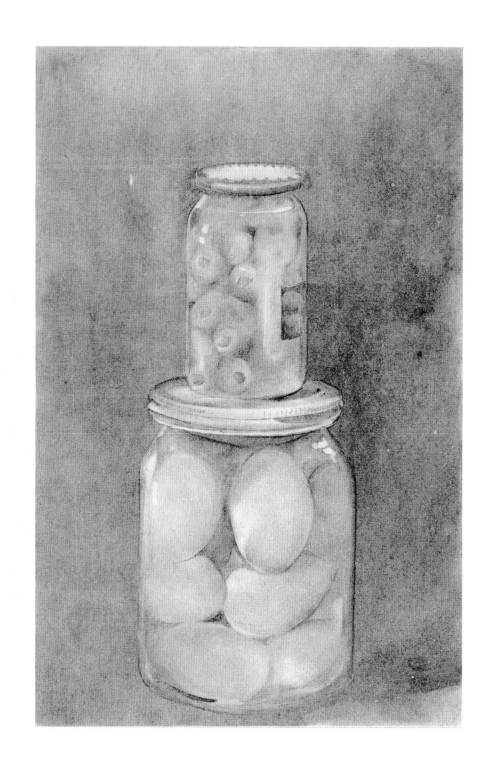

PIMENTOS AND PICKLED EGGS

1981, WATERCOLOR OVER MONOTYPE
IMAGE: 9"H × 6"W
PRIVATE COLLECTION, VALLEY OF THE MOON, CALIFORNIA

TO BE WASHED

(DETAIL)

1984, PRISMACOLOR AND GRAPHITE ON PAPER
$20^{1}/2$" H × 16" W

49

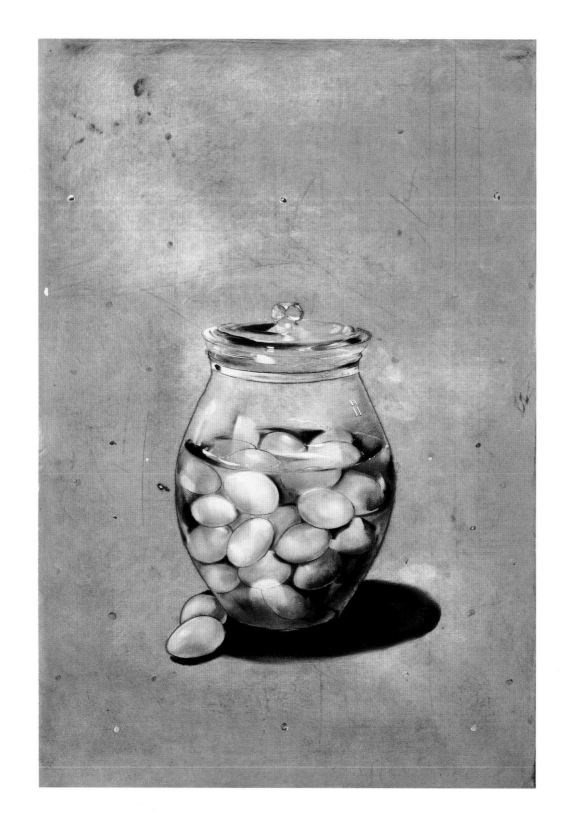

PICKLED

1988, PASTEL OVER MONOPRINT:
MONOTYPE AND DRYPOINT
IMAGE: 40"H × 27 1/4"W

COCKTAIL BURGER AND FOUR APPLES

1983, MONOTYPE
IMAGE: 9"H × 6"W
COLLECTION OF THEODORE AND FRANCES GEBALLE,
WOODSIDE, CALIFORNIA

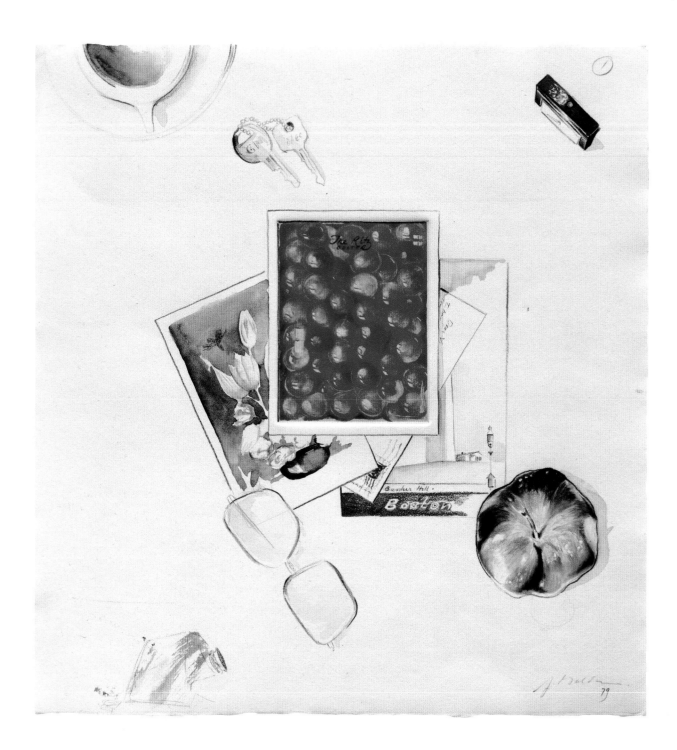

RITZ COLLAGE SKETCH, BOSTON

1979, PRISMACOLOR, WATERCOLOR, MONOTYPE
13⅝"H × 12⅞"W
PRIVATE COLLECTION, SAN FRANCISCO

PEEKEE

1983, PRISMACOLOR AND GRAPHITE ON PAPER
17"H × 15³/4"W
COLLECTION OF THE ARTIST

FLOWERS

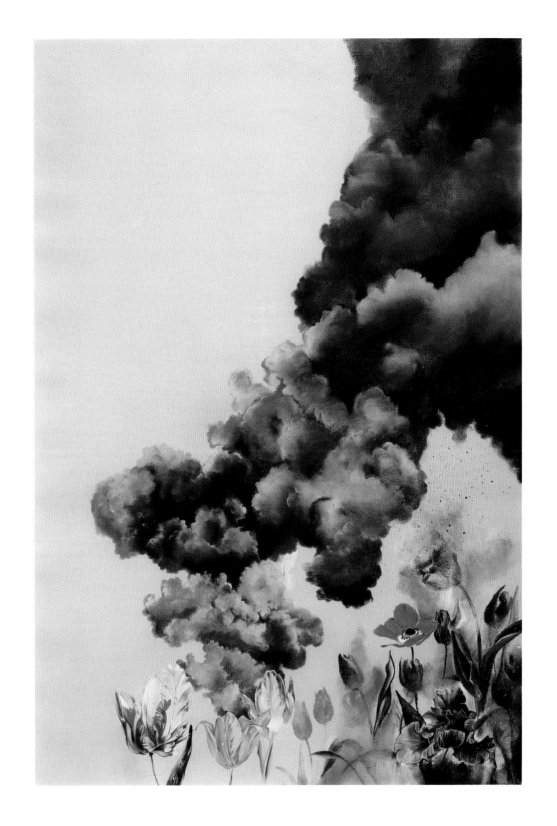

RIMBAUD'S GARDEN

1987, PASTEL ON PREPARED PAPER
44″ H × 29 3/4″ W

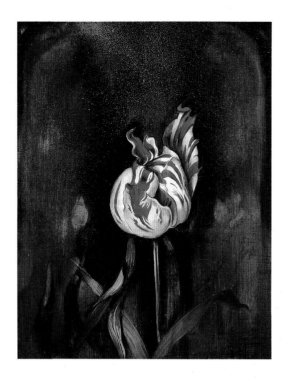

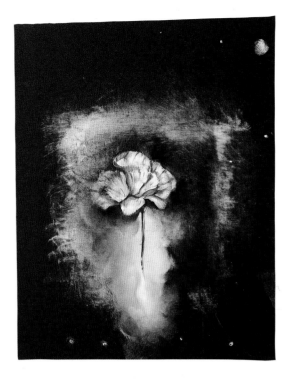

N I G H T T U L I P

1983, OIL PAINT ON GESSOED PANEL
10″ H × 8″ W
COLLECTION OF CARYLL AND WILLIAM MINGST,
PACIFIC PALISADES, CALIFORNIA

N I G H T P I N K

1987, WATERCOLOR OVER MONOTYPE
11 3/4″ H × 9 1/8″ W

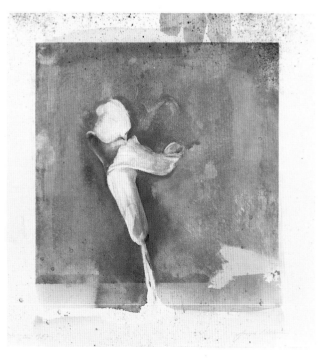

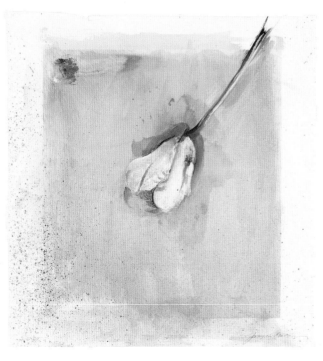

C U R L I N G L I L Y

1987, WATERCOLOR AND PASTEL
OVER MONOTYPE
13″ H × 12 1/2″ W

F A L L I N G T U L I P

1988, WATERCOLOR AND PASTEL
OVER MONOTYPE
11″ H × 11 3/4″ W
COLLECTION OF DITA AMORY, NEW YORK

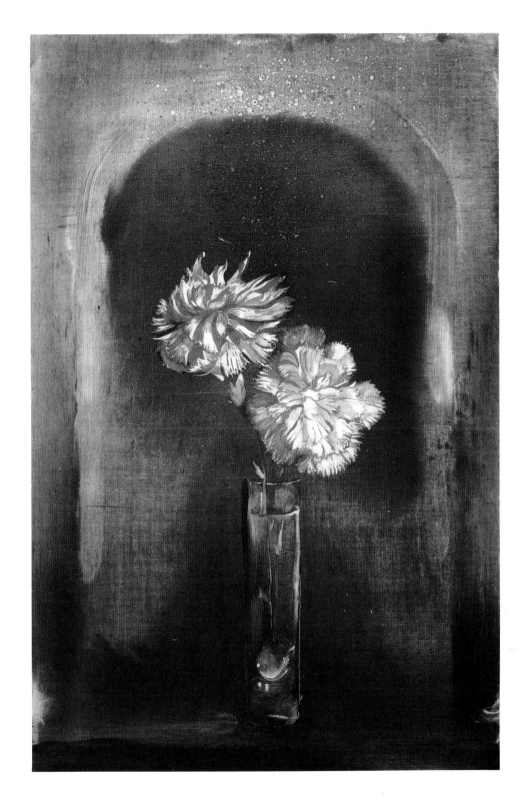

NIGHT PINKS

1983, MONOTYPE
IMAGE: 9″ H × 6″ W
PRIVATE COLLECTION, SAN FRANCISCO

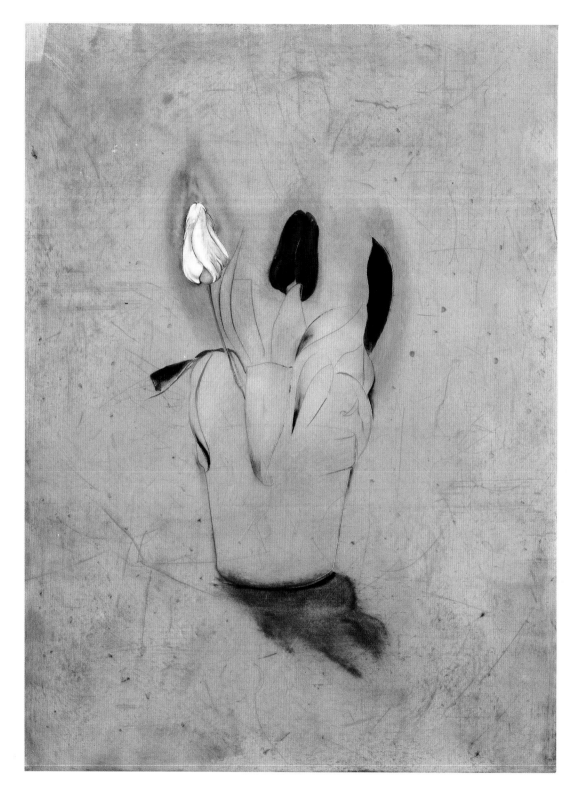

ELEGY ON SOUTHERN SOIL

1988, PASTEL OVER MONOPRINT:
MONOTYPE AND DRYPOINT
IMAGE: 47^{1}/$_{2}$"H × 35"W
PRIVATE COLLECTION, SAN FRANCISCO

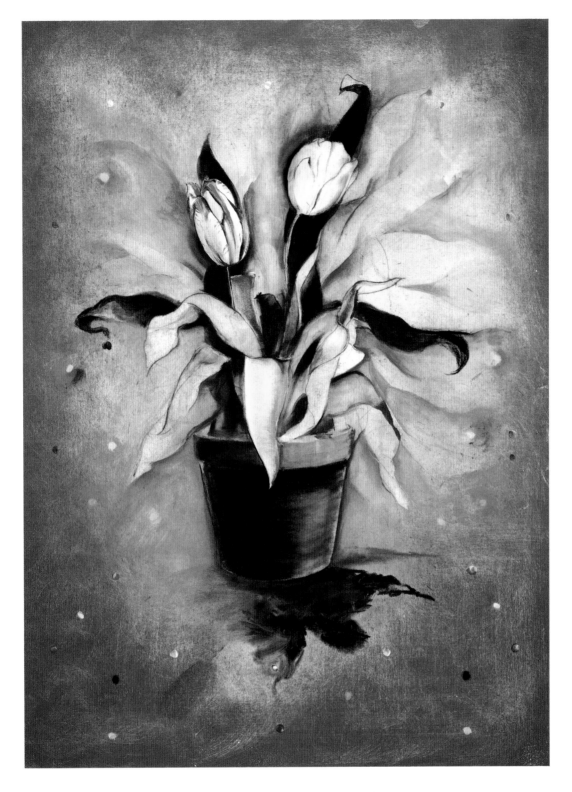

TOYMAKER'S TULIPS

1988, PASTEL OVER MONOPRINT:
MONOTYPE AND DRYPOINT
IMAGE: 47"H × 35"W
COLLECTION OF THE OAKLAND MUSEUM,
GIFT OF MRS. ALFRED J. GOLDYNE IN MEMORY
OF DR. ALFRED J. GOLDYNE

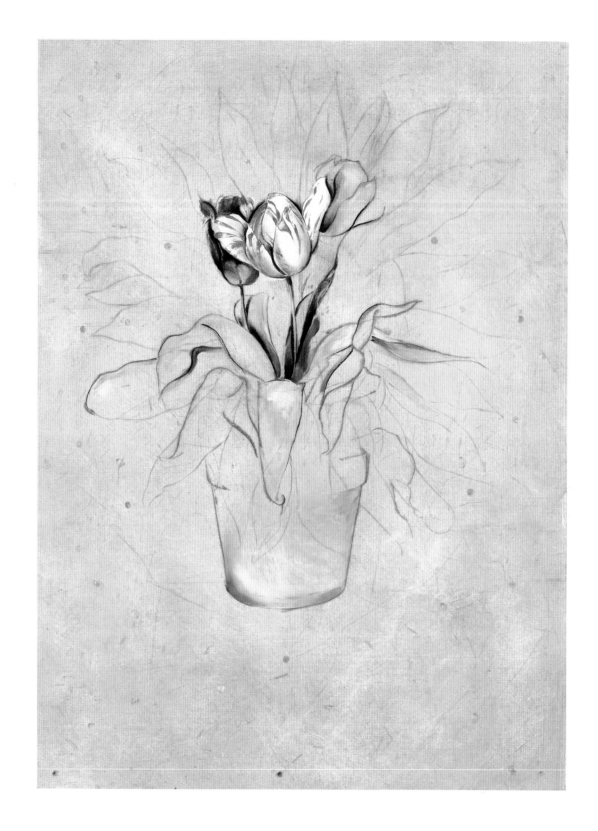

POSITION AND STATURE

1988, PASTEL OVER MONOPRINT: MONOTYPE AND DRYPOINT
IMAGE: 47"H × 35"W
COLLECTION OF MR. AND MRS. RON HATHAWAY,
SAN JOSE, CALIFORNIA

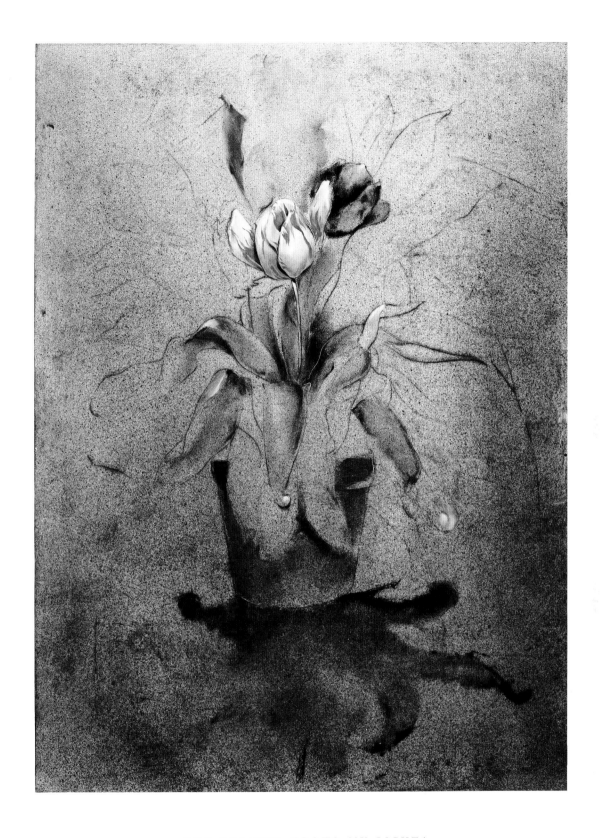

THE GREATER GROWS MY LIGHT/
THE FURTHER THAT I FLY

1989, PASTEL OVER MONOPRINT:
DRYPOINT AND MONOTYPE
47 1/2" H × 35" W

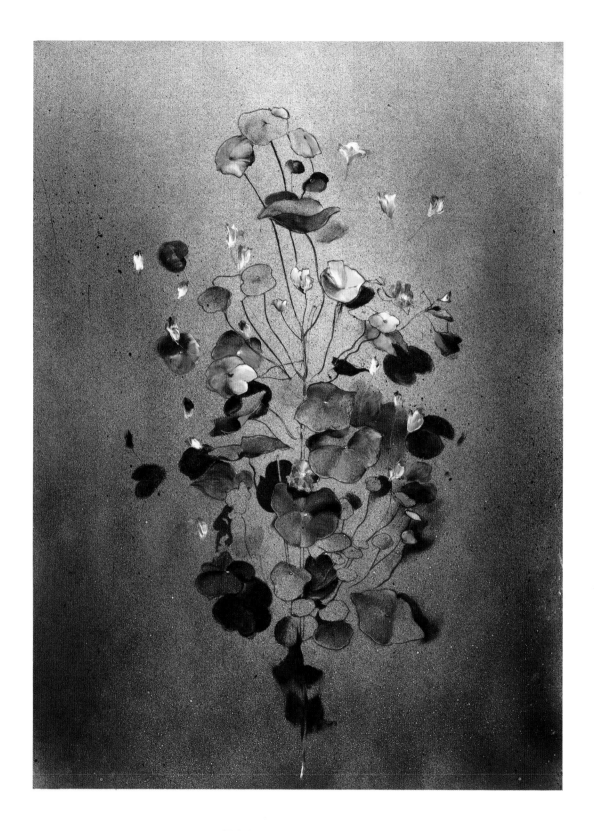

NASTURTIUMS II

1989, PASTEL OVER MONOPRINT:
MONOTYPE AND DRYPOINT
IMAGE: 47 1/2" H × 35" W

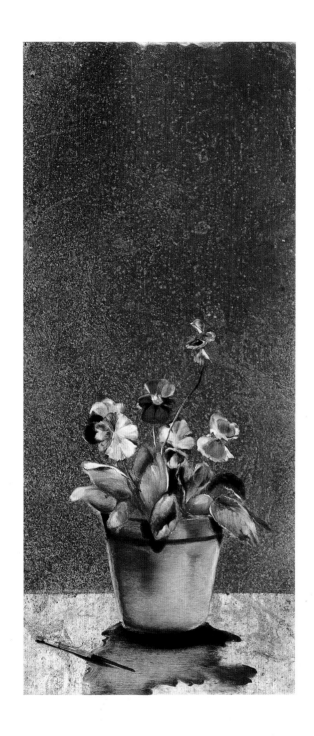

ISOLATED CONGREGATION

1988, PASTEL OVER MONOTYPE
IMAGE: 23$^{1}/_{2}$"H × 10$^{1}/_{4}$"W
PRIVATE COLLECTION, SIOUX CITY, IOWA

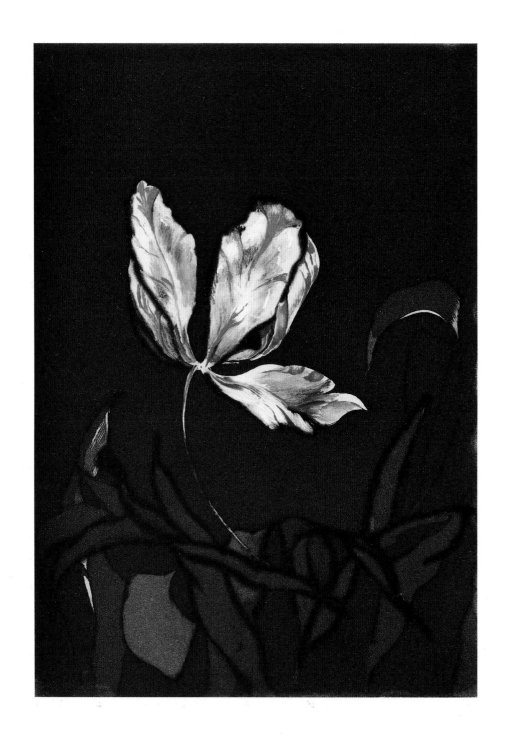

OPEN PARROT

1983, MONOPRINT: DRYPOINT, AQUATINT, MONOTYPE
IMAGE: $6^{7}/8''$ H \times $4^{7}/8''$ W
PRIVATE COLLECTION, SAN FRANCISCO

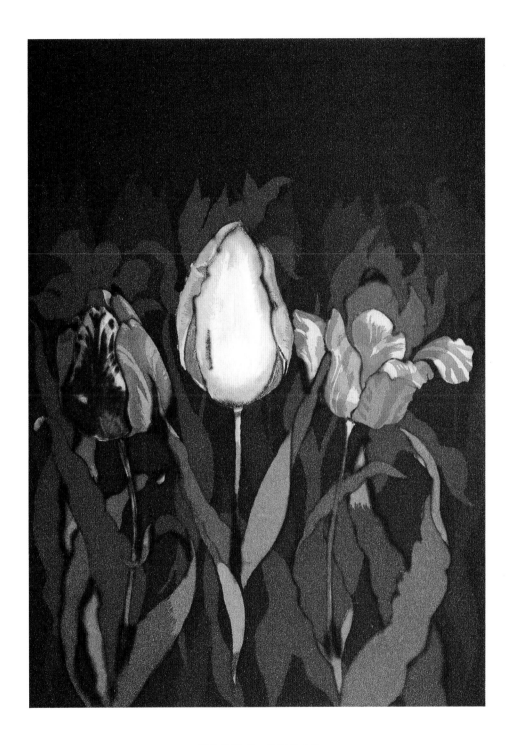

N I G H T C H O I R

(EDITION OF 20)
1983, AQUATINT AND DRYPOINT
IMAGE: 7"H × 5"W

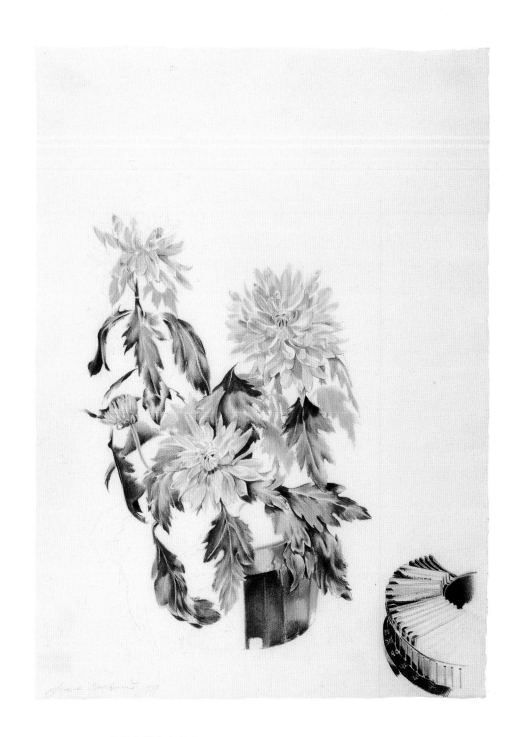

CHRYSANTHEMUMS AND CAROUSEL

1979, PRISMACOLOR AND GRAPHITE ON PAPER
15 15/16"H × 11"W

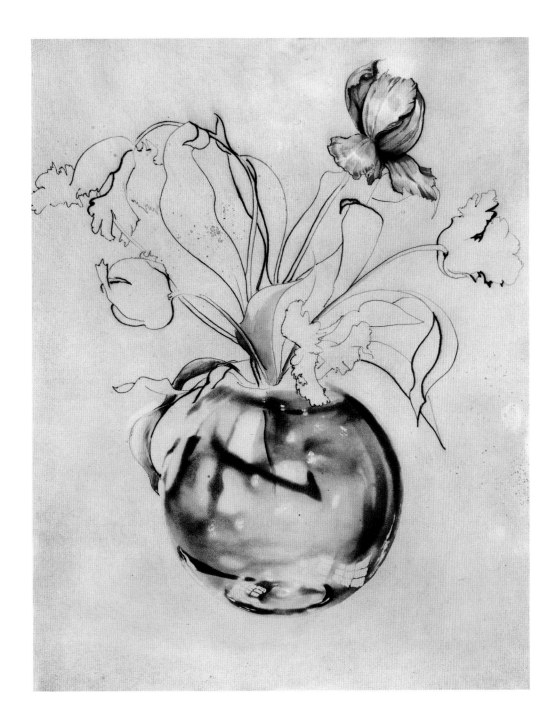

CRYSTAL, WATER AND TULIPS

1987, WATERCOLOR OVER MONOPRINT:
AQUATINT, DRYPOINT AND MONOTYPE
IMAGE: 14^{13}/16"H × 11^{7}/8"W

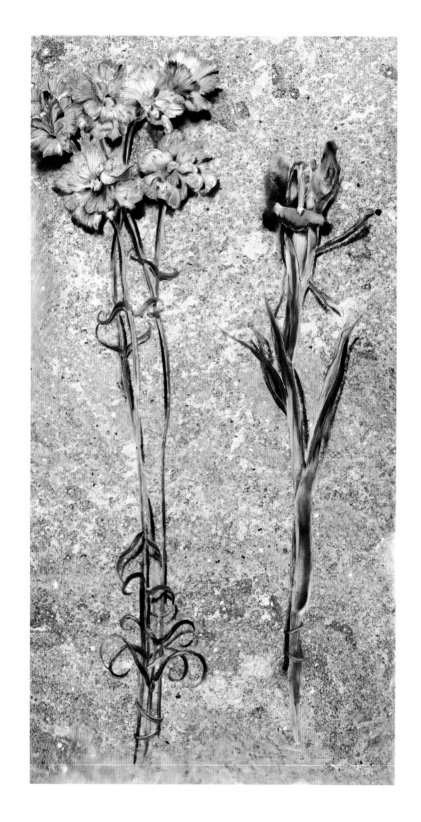

PINKS AND IRIS ON STONE

1989, PASTEL OVER MONOTYPE
IMAGE: $23^{3}/4"$ H \times $12^{1}/4"$ W

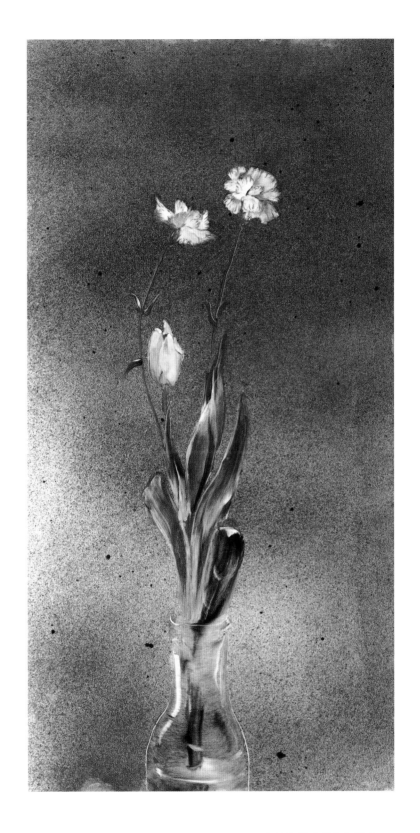

NIGHT EXERCISE WITH CARNATIONS
AND TULIP

1989, MONOTYPE
IMAGE: $23^{3/4}$" H × $12^{1/4}$" W

71

PORTRAITS

EAKINS TAKING QUESTIONS

1988, PRISMACOLOR AND GRAPHITE ON PAPER
25"H × 19 1/2"W

WINSLOW HOMER

1983, PRISMACOLOR AND GRAPHITE ON PAPER
20³/4″ H × 16″ W

HERR MENZEL SCHLAFT

1983, PRISMACOLOR ON PAPER
20"H × 16"W
PRIVATE COLLECTION, SAN FRANCISCO

EDWARD LEAR

1983, PRISMACOLOR ON PAPER
20¹/4″H × 16″W
PRIVATE COLLECTION, SAN FRANCISCO

DEGAS

1988, PRISMACOLOR AND GRAPHITE ON PAPER
20"H × 16"W
PRIVATE COLLECTION, SAN FRANCISCO

MONSIEUR CÉZANNE

1983, PRISMACOLOR ON PAPER
20"H × 16"W
COLLECTION OF THE FINE ARTS MUSEUMS OF SAN FRANCISCO,
ACHENBACH FOUNDATION FOR GRAPHIC ARTS (1983.2.46)

KOLLWITZ

1988, PASTEL OVER MONOTYPE GHOST
IMAGE: 37$\frac{1}{2}$"H × 24$\frac{1}{2}$"W

DEGAS

1988, PASTEL OVER MONOTYPE
IMAGE: $43^{5}/8''$ H \times $29^{1}/4''$ W
COLLECTION OF THE FINE ARTS MUSEUMS OF SAN FRANCISCO,
ACHENBACH FOUNDATION FOR GRAPHIC ARTS (1988.1.204)

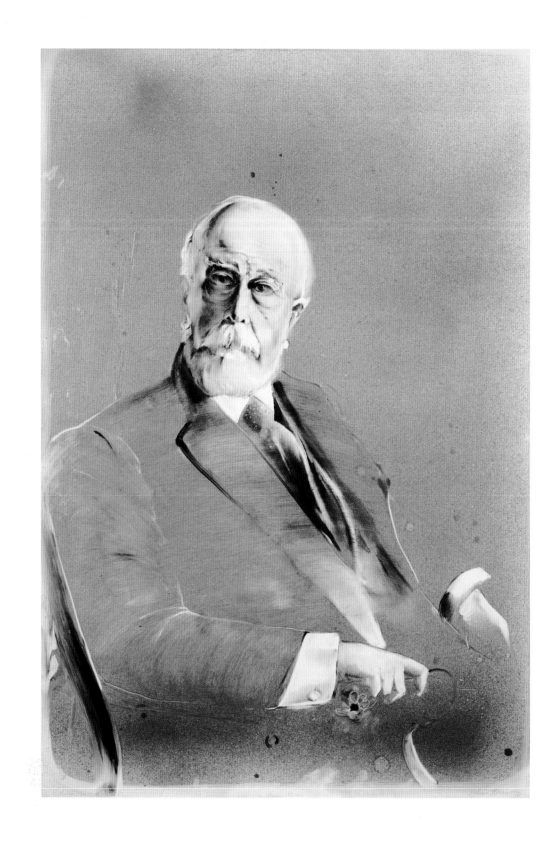

ODILON REDON

1988, PASTEL OVER MONOTYPE
44⅜"H × 30⅛"W

ELEVEN SKETCHES AROUND MELENDEZ

1988, MONOTYPE
44 3/8″ H × 30 1/8″ W

83

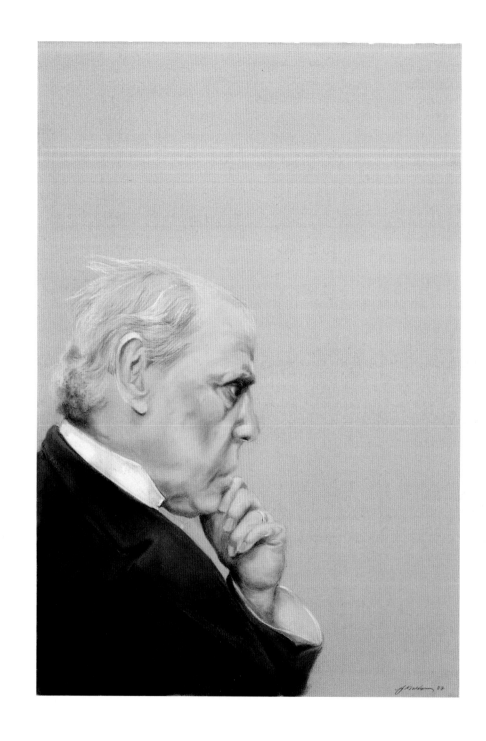

HENRY JAMES

1987, PASTEL AND GRAPHITE ON PREPARED PAPER
22¹/4″ H × 15″ W

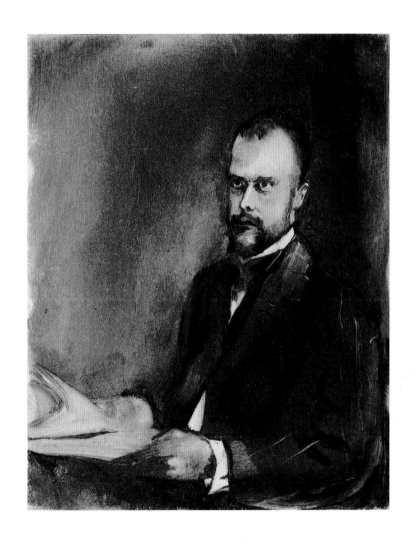

KLEE

1982, MONOTYPE
IMAGE: 5"H × 4"W

VIEWS

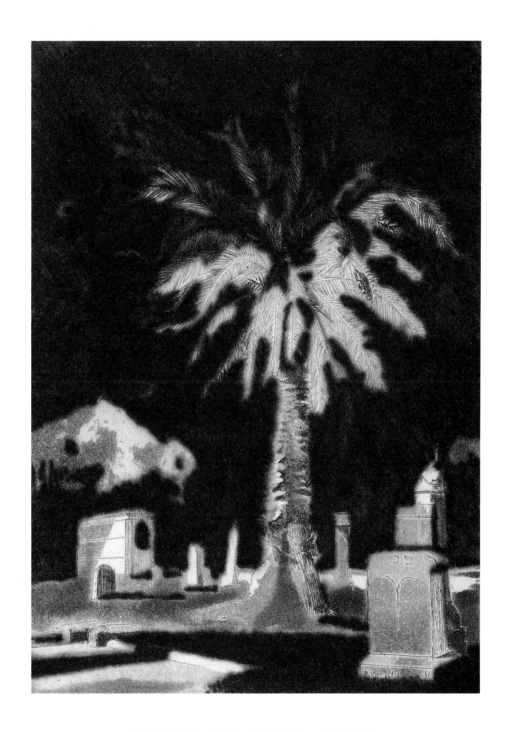

JEWISH CEMETERY, COLMA

(EDITION OF 6)
1981, DRYPOINT, AQUATINT, ETCHING
IMAGE: 7″H × 5¹/16″W

89

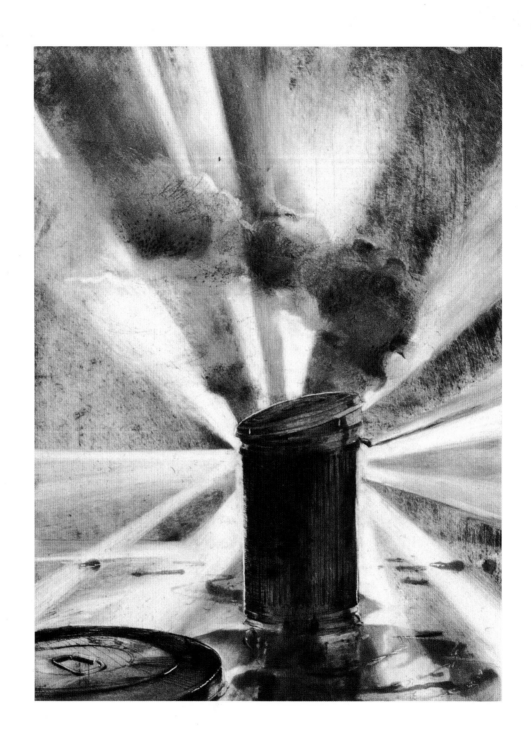

GARBAGE CAN WITH BEAMS

1979, MONOPRINT: ETCHING, AQUATINT, DRYPOINT, MONOTYPE
IMAGE: 11⁷/₈"H × 8¹³/₁₆"W
PRIVATE COLLECTION, SAN FRANCISCO

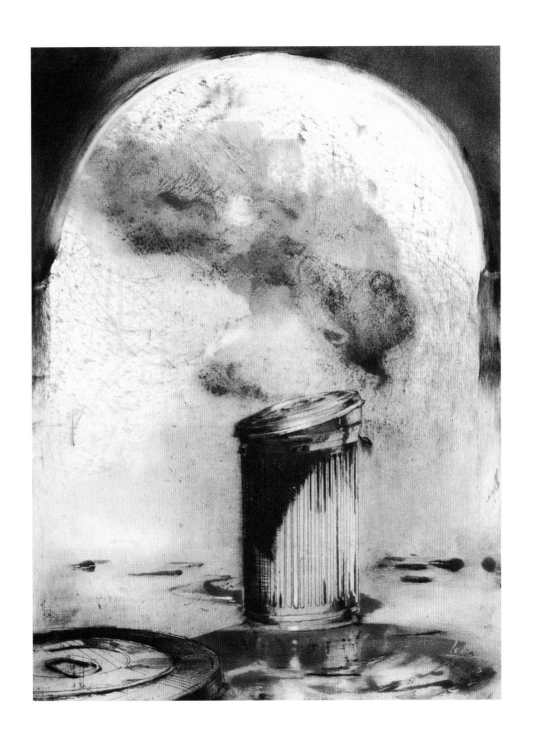

GARBAGE CAN WITH FLY SWARM IN
INCLEMENT WEATHER

1979, MONOPRINT: ETCHING, AQUATINT, DRYPOINT, MONOTYPE
IMAGE: 11 7/8″ H × 8 13/16″ W
COLLECTION OF THE ARTIST

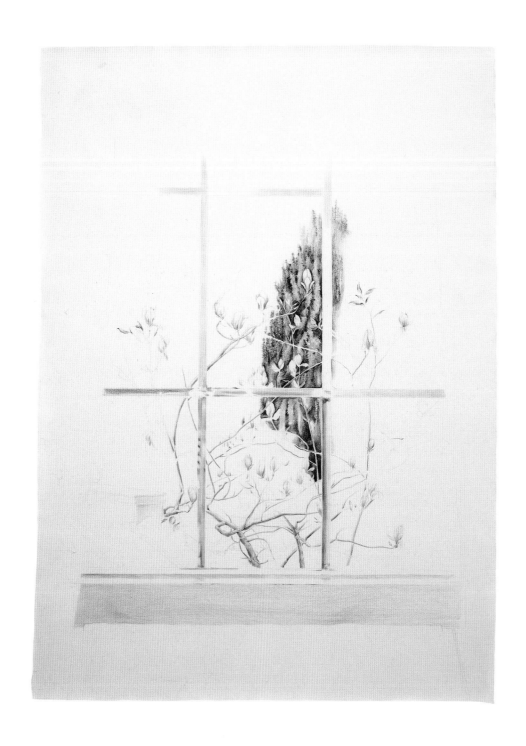

VIEW TOWARD CUL DE SAC, SAN FRANCISCO

C. 1980, PRISMACOLOR AND GRAPHITE ON PAPER
$30^5/8''$ H × $22^1/4''$ W
PRIVATE COLLECTION, SAN FRANCISCO

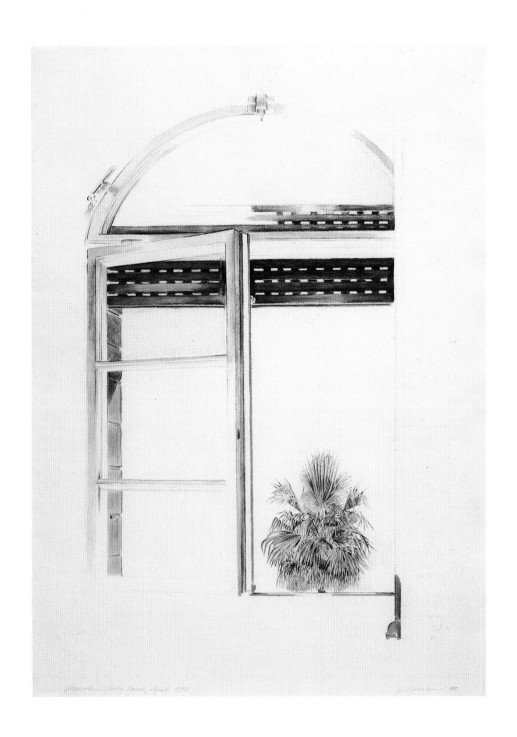

JERUSALEM, KING DAVID

1980, PRISMACOLOR AND GRAPHITE ON PAPER
15¼″H × 11⅛″W
PRIVATE COLLECTION, SAN FRANCISCO

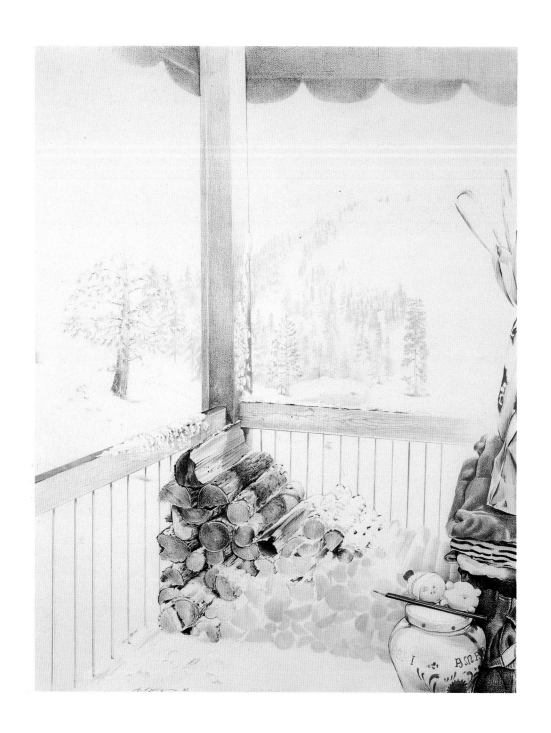

NORTHSTAR

1983, PRISMACOLOR AND GRAPHITE ON PAPER
21 7/8" H × 14 1/2" W
PRIVATE COLLECTION, SAN FRANCISCO

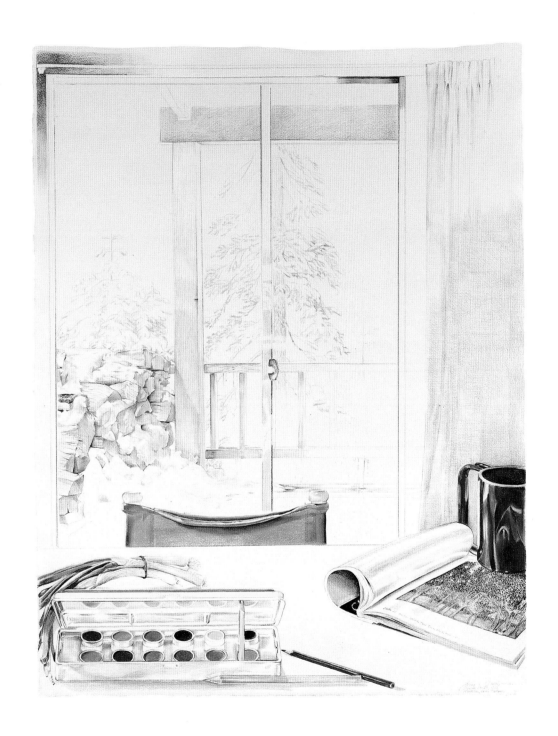

NORTHSTAR, LAKE TAHOE

1981, PRISMACOLOR AND GRAPHITE ON PAPER
20³/4"H × 16¹/4"W
FLAX COLLECTION, SAN FRANCISCO

A TULIP FOR KØBKE

1987, MONOTYPE
IMAGE: 9"H × 6"W

TAHOE, AUGUST 1986

1986, OIL PAINT ON GESSOED PANEL
14"H × 9 7/8"W
PRIVATE COLLECTION, SAN FRANCISCO

CASCADE

1987, WATERCOLOR, INK, AND GOLD LEAF
OVER MONOTYPE
IMAGE: 23 3/4″ H × 6 7/8″ W

SMOKE IN THE LIBRARY I

1988, PASTEL OVER MONOPRINT:
AQUATINT AND MONOTYPE
IMAGE: 24"H × 6"W
COLLECTION OF THE ARTIST

99

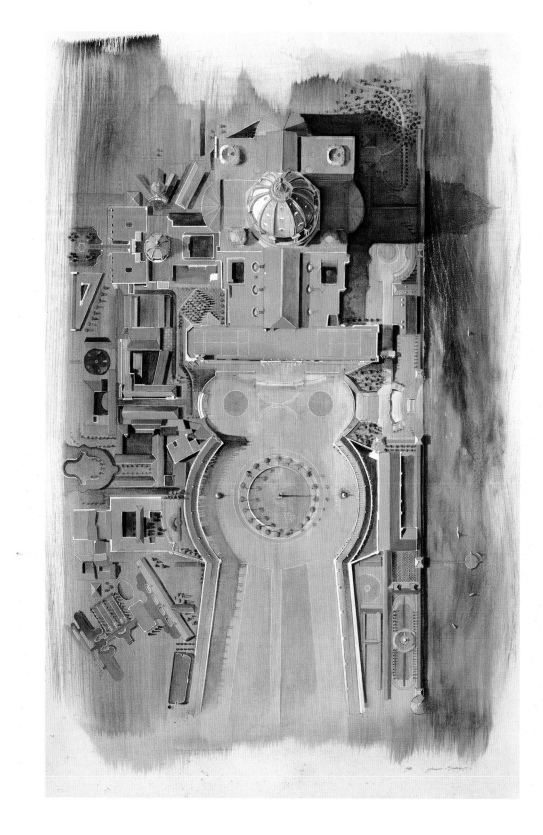

VATICAN VARIATION II: THE PRECINCT OF ST. PETER
RESTRUCTURED AND SITUATED ALONG THE SEA FOR
AERIAL DELECTATION

1988, OIL WASH, OIL PAINT, PENCIL, PASTEL, INK ON PAPER
36 3/4" H × 23 5/8" W

100

VATICAN IMPACT STUDY IV (THE SPARE VIEW DURING A
TIME OF MEASURED RESPONSE)

1988, PASTEL AND WATERCOLOR OVER MONOPRINT:
MONOTYPE AND DRYPOINT
47 1/2" H × 35" W

PIAZZA PINOCCHIO

1984, MONOTYPE
IMAGE: $8^{3}/4''$ H × $5^{7}/8''$ W

VATICAN IMPACT STUDY I

1988, PASTEL AND WATERCOLOR OVER MONOPRINT:
MONOTYPE AND DRYPOINT
47 1/4" H × 35" W
PRIVATE COLLECTION, SAN FRANCISCO

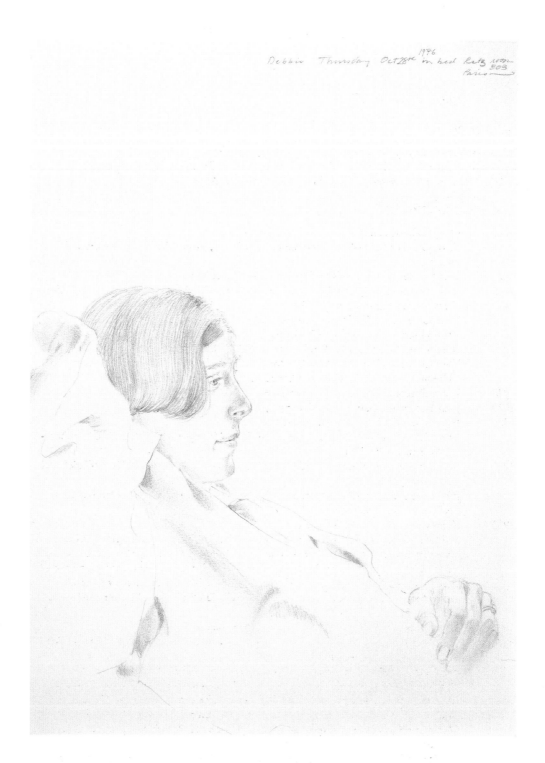

Debbie Thursday Oct 28th *1976* in bed Ritz room *303* Paris—

DEBBIE, RITZ, PARIS

1976, PENCIL ON PAPER (IN SKETCHBOOK)
12"H × 9"W
COLLECTION OF THE ARTIST

BIOGRAPHY

BORN

1942 Chicago, Illinois

EDUCATION

1960–64 University of California, Berkeley. A.B., Art History, 1964
1964–68 University of California School of Medicine, San Francisco. M.D., 1968
1968–70 Harvard University, Cambridge, Massachusetts. M.A., Fine Arts, 1970

SOLO EXHIBITIONS

1973 Quay Gallery, San Francisco, February 6–March 3.
 E. B. Crocker Art Gallery, Sacramento, California, *Joseph Goldyne, Monoprints*, April–
 May.
1974 Quay Gallery, San Francisco, September–October. Catalogue.
1975 U.S. Information Agency Bicentennial Exhibition, Washington, D.C., *Joseph Goldyne*.
 Traveled through Europe, 1975–76.
 Newport Harbor Art Museum, Newport Beach, California, *Joseph Goldyne / Color
 Monoprints*, December 3, 1975–January 11, 1976.
1976 Braunstein/Quay Gallery, San Francisco, September–October.
 Thomas Gibson Fine Art, Ltd., London, *Joseph Goldyne: An Exhibition of Monotypes and
 Monoprints*, October 14–November 11. Catalogue.
1978 James Corcoran Gallery, Los Angeles, April 15–May 11.
1979 John Berggruen Gallery, San Francisco, October.
1980 Impressions Gallery, Boston, January.
 James Corcoran Gallery, Los Angeles, *Goldyne: Monotypes and Drawings*, December 6,
 1980–January 10, 1981.
1981 Smith Andersen Gallery, Palo Alto, California, *Joseph Goldyne: Ten Years of Prints and
 Drawings*, June.
 John Berggruen Gallery, San Francisco, *Joseph Goldyne: Recent Work*, October 21–
 November 14. Catalogue.
1982 Klein Gallery, Chicago, September.
 National Museum of American Art, Smithsonian Institution, Washington, D.C.,
 Familiar But Unique / The Monoprints of Joseph Goldyne, September 24–December 5.
 Traveled to: The Fine Arts Center at Cheekwood, Nashville, Tennessee, January 6–
 February 20, 1983; Madison Art Center, Madison, Wisconsin, March–April 1983;
 Honolulu Academy of Arts, July–August 1983; San Francisco Museum of Modern
 Art, September–October 1983. Catalogue.
1983 John Berggruen Gallery, San Francisco, September.
1986 The Jewish Community Museum, San Francisco, *Anne Frank / Diary of a Young Girl:
 The Making of a Book*, January–March.
1987 New York Academy of Sciences, *Quartet*, February 12–March 27. Organized by
 NOVO Presents. Traveled to: The Chicago Academy of Sciences, April 22–August
 23; National Academy of Sciences, Washington, D.C., September 17–November 6;
 California Museum of Science and Industry, Los Angeles, November 20, 1987–
 February 15, 1988; The Exploratorium, San Francisco, March 1–April 18, 1988.
 Catalogue.
 Associated American Artists Gallery, New York, *Joseph Goldyne, Prints from Anne
 Frank*, March 3–28.
1989 Roger Ramsay Gallery, Chicago, April 13–May 17.
 Thomas Gibson Fine Art Ltd, London, October 31–December 15.

SELECTED GROUP EXHIBITIONS

1966 Gump's Gallery, San Francisco, December.

1967 Woodside Gallery, San Francisco.

1973 Stowe Gallery, Davidson College, Davidson, North Carolina, *Davidson National Print and Drawing Exhibition*, March–April. Purchase Award.

1974 Main Art Gallery, California State University, Sacramento, *National Print Invitational Exhibition 1974*, January 9–27. Brochure.

Smith Andersen Gallery, Palo Alto, California, *California Printmakers*.

Van Straaten Gallery, Chicago, *California in Print*, October 25–November 30.

1975 Palo Alto Cultural Center, Palo Alto, California, *Edition of One*, June 7–July 16. Catalogue.

National Collection of Fine Arts, Smithsonian Institution, Washington, D.C., *Twenty-Fourth National Exhibition of Prints*. Organized by the Library of Congress. Catalogue.

1977 Impressions Gallery, Boston, *West Coast Prints*.

Davidson Galleries, Seattle, *Footprint 1977*. Catalogue.

Thomas Welton Stanford Art Gallery, Stanford University, Stanford, California, *Stanford Monotypes*, Summer–Fall.

California State University, Los Angeles, *Miniature*, October 3–November 10. Catalogue.

1978 San Francisco Museum of Modern Art, *Six Printmakers*, July–September. Catalogue.

Stephen Wirtz Gallery, San Francisco, *Bay Area "12": Monotypes/Prints*, September–October.

Cooper-Hewitt Museum, New York, *Artists' Postcards II*, October–November. Traveled by the Smithsonian Institution Traveling Exhibition Service. Catalogue.

The Phillips Collection, Washington, D.C., *New American Monotypes*. Traveled by the Smithsonian Institution Traveling Exhibition Service, 1978–80. Catalogue.

1979 Marilyn Pearl Gallery, New York, *American Monotypes: One Hundred Years*, January.

Impressions Gallery, Boston, *Contemporary American Monotypes*, February–March.

1980 Allport Associates Gallery, Corte Madera, California, *Flowers: Prints and Monotypes*, April–May.

1981 Impressions Gallery, Boston, *Monotypes*, March–April.

Western Association of Art Museums, *Deja Vu: Masterpieces Updated*. Traveled 1981–82. Catalogue.

Impressions Gallery, Boston, *Views: Land and Sea*, July–August.

Newport Harbor Art Museum, Newport Beach, California, and Santa Barbara Museum of Art, Santa Barbara, California, *California: The State of Landscape, 1972–81*, July–September. Catalogue.

Klein Gallery, Chicago, October.

1982 New York Public Library, *Suites and Series: Eleven Artists*, March–June.

1983 Impressions Gallery, Boston, *Tulip Time*, May 5–31.

Fitch Febvrel Gallery, New York, *Discoveries in American Printmaking*, June 1–30.

San Francisco Museum of Modern Art, *World Print Four: An International Survey*, October 6–December 18. Catalogue.

Victoria Munroe Gallery, New York, *Small Paintings*.

1984 Santa Rosa Junior College Art Gallery, Santa Rosa, California, *The Poetic Image: Works by William Dole, Leon Goldin, Joseph Goldyne, and Arthur Lerner*, February 10–March 8.

Weintraub Gallery, New York, *Monotypes*, March 15–April 14.

Allport Associates Gallery, San Francisco, *Recent Bay Area Prints*, June 20–July 7.

Smith Andersen Gallery, Palo Alto, California, *Selected Monotypes*, October 19–November 21. Traveled to: Art Museum of Santa Cruz County, Santa Cruz, California, February 1985; Sheldon Memorial Art Gallery, University of Nebraska, Lincoln, November 1985; Art Collections, Arizona State University, Tempe, January 1986; Honolulu Academy of Arts, May 1986. Catalogue.

1985 The Chrysler Museum, Norfolk, Virginia, *Contemporary American Monotypes*, September 19–November 3. Catalogue.

De Saisset Museum, Santa Clara University, Santa Clara, California, *Contemporary Monotypes: Six Masters*, September 28–December 15. Catalogue.

1986 The Art Corridor, Sacred Heart Schools, Menlo Park, California, *The Purest Pigment: Pastel*, March 14–May 2.

Galleri Kulturtorvet, Copenhagen, *Selected Monotypes*, November 6–24.

1987 Oakland Museum, Oakland, California, *Cream of California Prints*, May 8–September 27. Brochure.

Stanford University Art Museum, Stanford, California, *The Anderson Collection: Two Decades of American Prints*, September 29, 1987–January 8, 1988. Catalogue.

San Jose Institute of Contemporary Art, San Jose, California, *Magnolia Editions*, October 27–November 25.

1988 Elizabeth Leach Gallery, Portland, Oregon, *Monotypes*, January.

Santa Rosa Junior College Art Gallery, Santa Rosa, California, *National Invitational Drawing Exhibition*, February 4–March 3.

Associated American Artists, New York, *Nightlife*, August 8–September 2. Catalogue.

John Berggruen Gallery, San Francisco, *Works on Paper*, September 8–October 8. Catalogue.

The Allport Gallery, San Francisco, *Recent Etchings from Made in California*, October 13–November 15.

Associated American Artists, New York, *Contemporary Still Lifes*, November 1–26. Brochure.

1989 Art Museum of Santa Cruz County, Santa Cruz, California, *Magnolia Editions: Works on Paper*, February 5–March 19.

Schmidt-Bingham Gallery, New York, *Artists' Artists, Portraits by Joseph Goldyne and Joyce Treiman,* June 21–July 21.

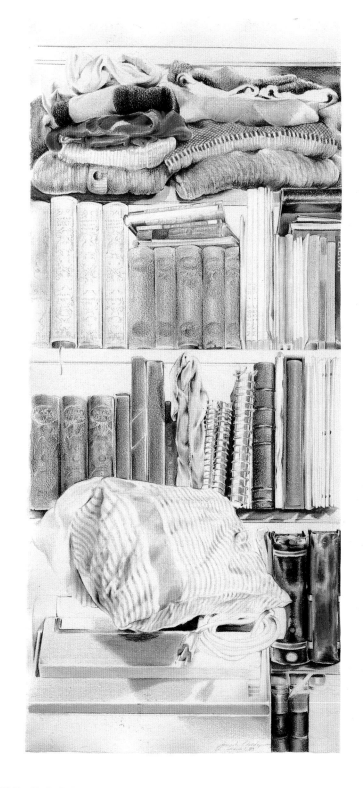

THE BOOKS OF MY NUMBERLESS DREAMS I
(FROM YEATS, "A POET TO HIS BELOVED")

1989, PRISMACOLOR AND GRAPHITE ON PAPER
21"H × 9¹/4"W

BIBLIOGRAPHY

CATALOGUES

Ballatore, Sandy. *Miniature*. Los Angeles: Fine Arts Gallery, California State University, 1977. Ill.: "Animal Crackers for Robert Hooke," 1976.

John Berggruen Gallery. *Works on Paper*. San Francisco, 1988. Ill.: "Vatican Variation II," 1988.

Clisby, Roger D. *Contemporary American Monotypes*. Norfolk, Va.: The Chrysler Museum, 1985. Ill.: Untitled ("Dark Floral"), 1979.

Cohn, Terri. *Contemporary Monotypes: Six Masters*. Santa Clara, Calif.: De Saisset Museum, 1985. Ill.: "A Berry Viewed as Tangential to Today's Art Concerns," 1975; "Night Pinks," 1983.

Cooper-Hewitt Museum. *Artists' Postcards II*. New York, 1978.

Davidson Galleries. *Footprint 1977*. Seattle, Wash., 1977.

Dobbs, Steven. "Old Jewels in a New Setting: The Monoprints of Joseph Goldyne" in *Joseph Goldyne* (translated into Rumanian). Bucharest: Biblioteca Americana, 1976.

Farmer, Jane M. *New American Monotypes*. Washington, D.C.: The Phillips Collection, 1978.

_____ . *Familiar But Unique: The Monoprints of Joseph Goldyne*. Washington, D.C.: National Museum of American Art, 1982.

_____ . *Selected Monotypes*. Palo Alto, Calif.: Smith Andersen Gallery, 1984. Ill.: "Guadagnini," 1984.

Thomas Gibson Fine Art, Ltd. *Joseph Goldyne*. London, 1976.

Holland, Katherine Church. *The Art Collection*. San Francisco: Federal Reserve Bank of San Francisco, 1986. Cover ill.: "Wrapped Tulips," 1981.

Lehrman, Roberta R. *Nightlife*. New York: Associated American Artists, 1988.

National Collection of Fine Arts. *Twenty-Fourth National Exhibition of Prints*. Washington, D.C.: Smithsonian Institution, 1975.

Quay Gallery. *Joseph Goldyne*. San Francisco, 1974.

Rice, Angele. *Edition of One*. Palo Alto, Calif.: Palo Alto Cultural Center, 1975.

San Francisco Museum of Modern Art. *World Print Four: An International Survey*. San Francisco, 1983.

Stanford University Art Museum. *The Anderson Collection: Two Decades of American Prints*. Stanford, Calif., 1987.

Tsujimoto, Karen. *Six Printmakers*. San Francisco: San Francisco Museum of Modern Art, 1978.

Turnbull, Betty. *California: The State of Landscape, 1972–81*. Newport Beach, Calif.: Newport Harbor Art Museum, 1981.

Western Association of Art Museums. *Deja Vu: Masterpieces Updated*. San Francisco, 1981.

Winter, David. *Joseph Goldyne*. San Francisco: John Berggruen Gallery, 1981. Ill.: "Northstar, Lake Tahoe," 1981; "Pail, Trunks and Lily," 1980; "Open-Face and Slab of Salmon," 1981; "Epitonium Scalare," 1981; "Pale Arrangement in Can," 1980; "Pimentos," 1981.

BOOKS ILLUSTRATED BY THE ARTIST

Frank, Anne. *Het Achterhuis / Anne Frank: Diary of a Young Girl.* West Hatfield, Mass.: Pennyroyal Press with Jewish Heritage Publishing, 1985. Designed by Barry Moser; printed by Harold McGrath. Illustrated with ten etchings by Joseph Goldyne. Edition of 450.

Goldyne, Joseph. [Jeremy Roland, pseud.]. *Gathering the Decade.* San Francisco: Goad Press, 1972. Printed by Grabhorn-Hoyem, San Francisco. Illustrations by Joseph Goldyne.

Guerin, Maurice de. *Le Centaure.* Berkeley, Calif.: Arif Press, 1986. Illustrated with etching by Joseph Goldyne. Edition of 65.

Thomas, Lewis. *Quartet.* San Francisco: Pacific Editions, and Berkeley, Calif.: Arif Press, 1986. Handset and printed by Wesley B. Tanner. Illustrated with five color etchings by Joseph Goldyne. Edition of 130.

BROCHURES

Associated American Artists. *Contemporary Still Lifes.* New York, 1988.

Heyman, Therese Thau. *Cream of California Prints.* Oakland, Calif.: The Oakland Museum, 1987.

Main Art Gallery, California State University. *National Print Invitational Exhibition 1974.* Sacramento, 1974.

FILMS / VIDEOS

Draisin, Dan. *The California Draftsmen: Joseph Goldyne.* New York: The Drawing Society, 1985 (15-minute video).

SELECTED ARTICLES

Albright, Thomas. "These Outrages Are Sensitive." *San Francisco Chronicle*, February 23, 1973, p. 48.

————. "Treasurable Titles and Spoofs on Surrealism." *San Francisco Chronicle*, December 14, 1976, p. 47.

Allen, Jane Addams. "Bay Area, Scandinavia on Canvas." *Washington Times*, October 8, 1982, pp. 1B–2B.

"American Impressions." *Diversion Vacation Planner*, July–August 1983, p. 75.

Baker, Kenneth. "Prints That Are One of a Kind." *San Francisco Chronicle*, November 7, 1985.

Bartholomew, Caroline. "Cheekwood Displays Works by Goldyne." *Nashville Banner*, February 17, 1983, pp. B6–7. Ill.: "Goya's Bull Coming in Over Marin."

Bloomfield, Arthur. "A Painter and His Co-Artists Out of the Past." *San Francisco Examiner*, September 4, 1974, p. 20. Ill.: "Jolie: P.P. and BLT."

Burkhart, Dorothy. "Experimenting with Monotype." *San Jose Mercury News*, October 25, 1985, p. 16E.

Cebulski, Frank. "A Microcosm of Printmaking." *Artweek*, vol. 14, no. 42, December 10, 1983, pp. 5–6.

Cervenak, Tom. "Joseph Goldyne." *Pacific Sun*, September 19–25, 1974, pp. 2–3. Ill.: "Ruscha and the Number One Impressionist"; "A Bouquet from and for Manet"; "Goya's Salmon Steak and Rembrandt's Shell."

Doss, Margaret Patterson. "An Upstairs Tour of the Galleries." *S.F. Sunday Examiner and Chronicle*, December 5, 1976, p. 6.

"Exhibit Focuses on Quay Gallery Influence." *Palo Alto Times*, September 8, 1975, sec. II, p. 9. Ill.: "De Kooning's Pink Angel Appears Over an Elysian Stable at Dusk" (version 1), 1974.

Fried, Alexander. "Artist Sees Double." *San Francisco Examiner*, February 1973. Ill.

Hagen, Carol. "Joseph Goldyne." *Artweek*, September 21, 1974, p. 3. Ill.: "De Kooning's Pink Angel Appears Over an Elysian Stable at Dusk," 1974.

Hieronymus, Clara. "Goldyne's Images May Be Small, But They Bring a Big Smile." *The Tennessean*, January 27, 1983, sec. C. Ill.: "Dusk Arc Pane," 1979; "Red Tulip"; "Narcissus."

Johnson, Lincoln. "Print Exhibit: Seeking Direction by Reviewing Past." *The Sun* (Baltimore, Md.), June 12, 1975, p. B7.

"Joseph Goldyne." *The Print Collector's Newsletter*, vol. 19, no. 2, May–June 1988, p. 62.

"Joseph Goldyne at The National Museum of American Art." *Antiques Review*, October 1982, p. 7. Ill.: "A Headwind for Homer: Winslow's Becalmed Lady Approached by Gentileschi's Glowing Turban."

Koland, Cordell. "Modern 'Monotype' Masters Display Their Diversity." *Business Journal*, November 18, 1985.

Loach, Roberta. "Joseph Goldyne in Conversation with Roberta Loach." *Visual Dialog*, vol. 4, no. 4, July–September 1979.

"The Monoprints of Joseph Goldyne." *Journal of the Print World*, Fall 1982.

"The Monoprints of Joseph Goldyne." *Antiques & The Arts Weekly*, November 19, 1982, pp. 68–69. Ill.: "Goya's Bull Coming in Over Marin" (version 3), 1973; "De Kooning's Pink Angel Appears Over an Elysian Stable at Dusk" (version 1), 1974; "Facets: Little Macchiaioli Flowerpots Reverie," 1977; "Palm Promenade," 1981; "Homage to the Tight Fit and to Vuillard," 1976.

Morse, Marcia. "Monoprints." *The Sunday Star-Bulletin & Advertiser* (Honolulu), July 24, 1983, p. C8. Ill.: "19."

"News of the Print World: People & Places." *The Print Collector's Newsletter*, vol. 19, no. 2, May–June 1988, p. 55.

Ostrow, Joanne. "Joseph Goldyne Masters the Pun." *The Washington Post*, September 24, 1982, p. 31.

Paris, Harold. "Joseph Goldyne—A New Talent." *Artweek*, vol. 4, no. 7, February 17, 1973, pp. 1 & 12. Ill.: "San Francisco from Parnassus with Floating Toledo, Lemon Slice and Cherries"; "Floating Boudin with Garbage Can."

Rhem, James. "From Colossal to Quiet at MAC." *The Capital Times* (Madison, Wisc.), March 29, 1983, pp. 29–30. Ill.: "For Harold."

Richard, Paul. "Museums." *Washington Post*, September 12, 1982.

Tarshis, Jerome. "Joseph Goldyne at the Museum of Modern Art and John Berggruen." *Art in America*, vol. 71, no. 1, January 1984, p. 137.

_____ . "Unusual Masterpieces." *The Christian Science Monitor*, April 27, 1984, p. 30. Ill.: "Ruscha and the Number One Impressionist (Version 1)."

"Top Picks." *Washington Times*, November 19, 1982. Ill.: "Toy Mouse Surveying a Vanitas Arrangement."

"U.S. Bicentenary Revolution: Concert and Exhibition." *The Bulletin* (Valetta, Malta), February 16, 1976.

Winter, David. "Goldyne Weaves the Old into Vividly New Contexts." *Peninsula Times Tribune*, October 12, 1983, p. C3.

_____ . "Joseph Goldyne" in "Artists the Critics Are Watching." *Art News*, vol. 83, no. 9, November 1984, pp. 93–94. Ill.: "Parade."

Zelcher, Al, Jr. "Works of Six Masters Highlights De Saisset's Fall Opening." *The Santa Clara*, October 3, 1985, p. 13.

TECHNICAL ASSISTANTS

Whereas the great majority of Joseph Goldyne's graphic work has been devoted to drawings and unique prints, he has continued to do edition prints from the beginning of his efforts in printmaking.

His earliest intaglio editions were pulled by Robert Townsend in 1969 and 1970 at Impressions Workshop, Boston, Massachusetts. Mr. Townsend also assisted him while he worked on early monoprints.

The artist's earliest lithographs (1969–70) were editioned by Herb Fox and Paul Maguire at Impressions Workshop. Mr. Maguire also printed some later lithographic editions for Goldyne.

In 1971, the artist began to work in the studio of Jeanne Gantz in Berkeley, California, where his first color monoprints were done with her encouragement (e.g. pages 13, 27–33, and 36–37). Mrs. Gantz with the assistance of David Kelso printed most of Goldyne's edition prints between 1976 and 1978 (e.g. pages 34–35).

David Kelso established his own studio *Made in California* in Oakland, California, in 1980 where several Goldyne editions were printed (e.g. pages 66–67 and 89). 3EP in Palo Alto, California, also provided services in the preparation and printing of edition prints under the supervision of Lee Altman and Ikuru Kuwahara.

The plates for Anne Frank (e.g. page 20) as well as many other works were created by the artist at Katherine Lincoln Press, San Francisco, with the encouragement and assistance of Kay Bradner. Ms. Bradner pulled the à la poupée proofs at the press and they were editioned by Kate Hanlon at Robert Townsend Inc. in Georgetown, Massachusetts.

At Magnolia Editions in Oakland, California, Rick Dula, Donald Farnsworth, and Stuart McKee have assisted the artist on lithographic and intaglio editions, and Donald Farnsworth has offered important technical assistance on Goldyne's latest large monotypes (e.g., pages 23, 60–64, and 80–83).

Recently, Mark Johnson has printed several small editions at Joseph Goldyne's studio in Sonoma, California.